Art and the Excited Spirit:
America in the Romantic Period

ART AND THE EXCITED SPIRIT

AMERICA in the ROMANTIC PERIOD

An Exhibition Organized by
DAVID CAREW HUNTINGTON

assisted by **EDWARD R. MOLNAR**

ROBERT A. YASSIN, Editor

THE UNIVERSITY OF MICHIGAN MUSEUM OF ART
ANN ARBOR
1972

This publication and the exhibition are supported by a grant from the
National Endowment for the Arts, Washington, D.C., a Federal Agency

Cover illustration:
no. 116
John Quidor (1801–1881)
Wolfert's Will (detail), 1856
Lent by The Brooklyn Museum, Dick S. Ramsay Fund

Preface.

The past two decades have been marked by a substantial awakening of interest in the history of the arts of the United States of the mid-nineteenth century. A new generation of critics and art historians has shed needed light on the work of artists who had become relatively anonymous and encouraged a reappraisal of their work in a contemporary context. Together with the collectors, museums, and art dealers who have followed their lead, they have brought into focus the visual arts and especially their interrelationship with the literature and social history of the time.

David Huntington, Associate Professor of History of Art at The University of Michigan, is among the pioneers of this new vision. Professor Huntington re-introduced us to the work of Frederic Edwin Church in an in-depth exhibition organized by the National Collection of Fine Arts, Smithsonian Institution, in 1966. Concurrently his monograph, *The Landscapes of Frederic Edwin Church: Vision of an American Era,* presented in more extended form the concepts suggested in the exhibition. Professor Huntington was also active in establishing Olana, Church's Moorish-Italianate villa on the banks of the Hudson River, designed and erected in collaboration with the architect Calvert Vaux, as a national historic site.

Now, in the exhibition, *Art and the Excited Spirit: America in the Romantic Period,* Professor Huntington explores a similar theme in a much broader context. As he summarized the nature and purpose of the exhibition in his original proposal, and develops in much more detail in the essay which follows, it is "to demonstrate the consistency of style and sensibility which characterize the creations of the self-conscious artist in our romantic period; the painter, the sculptor, the architect, the furniture designer—all worked within the same form system to express a wide range of human emotions."

The publication of this catalogue follows by several months the exhibition which provided its particular frame of reference. It is preceded by a checklist published concurrently with the exhibition itself. The exhibition and this catalogue represent part of a cycle of related exhibitions and publications which have been the product of collaboration between The University of Michigan Museum of Art, the Department of History of Art, and other University departments of instruction. In this instance, the Program in American Culture has also been especially involved as a co-sponsor of the lectures held in connection with the exhibition. We also acknowledge with gratitude a supporting grant from the National Endowment for the Arts, on recommendation of its Advisory Panel on Museum Programs, and the interest of the former Director of these Programs, Thomas W. Leavitt, Director of the Andrew Dickson White Museum, Cornell University.

An exhibition of this essentially subjective and didactic nature, involving a variety of media and a multiplicity of subject matter, poses particular problems in selection and organization. In this instance we have had the cooperation and generous support of fifty-five institutions and individual lenders, and well over a hundred collectors, museum officials, and scholars who have provided essential assistance and information in connection with the assembling of the exhibition and the documentation of the catalogue. These are included in the lists of acknowledgements which follow. I wish also to express personal appreciation and that of the museum to Robert A. Yassin, Acting Associate Director, and to Mrs. Doris Borthwick and to Mrs. Margaret Riddle who have assisted him in the preparation and editing of the catalogue; to the museum curators, Mrs. Nesta Spink and John Holmes, who had primary responsibility for the installation of the exhibition; and to the Museum Registrar, Mrs. Carol C. Clark, and to her associate, Patricia Whitesides, for their devoted and successful planning which brought the objects successfully together and assured their safe return to their respective owners. Also, the interest and involvement of John R. Hamilton, Editor, University Publications, and the members of the University Printing

Services is recorded with continued appreciation. Finally, we express our particular gratitude to Professor Huntington, for without his own initiative, enterprise, and continued concern this exhibition and the accompanying catalogue would have remained a concept rather than a reality.

Charles H. Sawyer
Director

Lenders to the Exhibition.

Addison Gallery of American Art, Phillips Academy, Andover, Massachusetts

American Antiquarian Society, Worcester, Massachusetts

Anonymous Lender

Mr. Robert Bishop, Dearborn, Michigan

Boston Athenaeum

Mr. and Mrs. Kenneth E. Brooker, Bloomfield Hills, Michigan

The Brooklyn Museum

Dr. and Mrs. Irving F. Burton, Huntington Woods, Michigan

Carolina Art Association, Charleston, South Carolina

Cincinnati Art Museum

William L. Clements Library, The University of Michigan, Ann Arbor

Cooper-Hewitt Museum of Decorative Arts and Design, Smithsonian Institution, New York

Corcoran Gallery of Art, Washington, D.C.

Galleries—Cranbrook Academy of Art, Bloomfield Hills, Michigan

Dartmouth College Collection, Hanover, New Hampshire

The Detroit Institute of Arts

The Dietrich Brothers Americana Corporation, Philadelphia

Fogg Art Museum, Harvard University, Cambridge, Massachusetts

Henry Ford Museum, Dearborn, Michigan

Mr. Henry Melville Fuller, New York

Jo Ann and Julian Ganz, Jr., Los Angeles

Mr. and Mrs. Charles V. Hagler, Ypsilanti, Michigan

Joseph H. Hirshhorn Collection, New York

Hirschl and Adler Galleries, New York

Joslyn Art Museum, Omaha, Nebraska

Steven and Jenay Katkowsky, Ypsilanti, Michigan

Kennedy Galleries, Inc., New York

Library of Congress, Washington, D.C.

Meredith Long and Company, Houston, Texas

The Metropolitan Museum of Art, New York

The Mint Museum of Art, Charlotte, North Carolina

Montclair Art Museum, Montclair, New Jersey

Museum of Art, Rhode Island School of Design, Providence

Museum of Fine Arts, Boston

Museum of the City of New York

National Portrait Gallery, Smithsonian Institution, Washington, D.C.

The Newark Museum, Newark, New Jersey

New-York Historical Society, New York City

New York State Historical Association, Cooperstown

Olana Historic Site, Hudson, New York

Peabody Museum of Salem, Salem, Massachusetts

Pennsylvania Academy of the Fine Arts, Philadelphia

Philadelphia Museum of Art

Mr. and Mrs. S. Dillon Ripley and Mrs. Gerald M. Livingston

Acknowledgements.

Professor David Huntington and The University of Michigan Museum of Art wish to acknowledge with gratitude the assistance which the following individuals have given in arranging for loans for the exhibition or in providing essential information for the catalogue:

Philip R. Adams; Thomas N. Armstrong III; Albert K. Baragwanath; George Bird; Robert Bishop; Alfred Blomberger; Richard Boyle; Carleton Brown; Charles E. Buckley; Mrs. Georgia B. Bumgardner; Joseph T. Butler; Janet S. Byrne; Duncan F. Cameron; Charles Chetham; Kenneth C. Cramer; Frederick Cummings; Lawrence Curry;

Mrs. Elaine E. Dee; H. Richard Dietrich, Jr.; Ernest S. Dodge; Wilson Duprey; Charles H. Elam; James Elliott; Jonathan Fairbanks; Sarah Faunce; Stuart Feld; Lawrence A. Fleischman; Patricia Foster; Kathryn E. Gamble; Jane des Grange; Mrs. Lucretia H. Giese; Mrs. Katharine B. Hagler; James J. Heslin; Mrs. May Davis Hill; Norman Hirschl; Walter Hopps; John K. Howat;

John Jacobus; Harriet C. Jameson; Mrs. Sumner C. Johnston; Louis Jones; Milton Kaplan; Elizabeth Kirchner; Mrs. Katheryn Kortheuer; Cecily Langdale; Martin Leifer; Abram Lerner; Irving Levitt; June N. Lollis; Ann Manarino; J. Patrice Marandel; Peter O. Marlow; Mrs. Cynthia Jaffee McCabe; Marcus A. McCorison; Mrs. Mildred S. McGill; William A. McGonagle; John J. McKendry; William McNulty; Robert F. W. Meader; Samuel C. Miller; Martha Morris;

Joseph V. Noble; Stephen E. Ostrow; Howard H. Peckham; John D. Peterson; James Pilgrim; Perry T. Rathbone; Sue Welsh Reed; Daniel Robbins; Anne Rogerson; Christian Rohlfing; Marvin S. Sadik; Herbert J. Sanborn; Eleanor Sayre; Beverly Schultz; Ellen Sharp; Alan Shestack; Richard E. Slavin III; Philip C. F. Smith;

Susan Solomon; Robert E. Springer; Robert G. Stewart; June C. Stocks; Elizabeth Strassmann; Joshua G. Taylor; Richard Teitz; Antoinette Thiras; Minor Wine Thomas, Jr.; Evan H. Turner; Donald Walters; Marilyn Wheaton; Robert P. Weimann; Robert Wheeler; Walter M. Whitehill; Willis F. Woods.

Art and the Excited Spirit.

by *David Carew Huntington*

> While the student ponders this immense unity, he observes that all things in Nature, the animals, the mountain, the river, the seasons, wood, iron, stone, vapor, have a mysterious relation to his thoughts and his life; their growths, decays, quality and use so curiously resemble himself, in parts and in wholes, that he is compelled to speak by means of them. (Ralph Waldo Emerson, *Poetry and Imagination*)

Our ancestor who lived in the years between the War of 1812 and the Civil War perceived his universe as a vast moral theater. His eyes were ceaselessly on the watch for the glimmer or the glow of God's signature, his ears were ceaselessly on the alert for the whisper or the thunder of God's voice. Our ancestor was ever ready to perceive the manifestation of the holy. Anything that met his glance might strike his moral fancy. In a hero's face, an eagle's flight, a mountain's dome, a church's spire he beheld the divine; in a miser's face, a snake's coil, a threatening cliff, a heathen palace, he beheld the demonic. Ever conscious of deity and concerned with destiny, our ancestor lived in an aura of expectancy. The phrenologist was primed to measure a portion of the soul in the head-bump; the table-rapper, ready to interpret mysterious tappings; the Millennialist, prepared to recognize the fulfillment of prophecy; the Transcendentalist, disposed to discover the cosmic mystery in the smallest particular. The American of the Romantic age was wakeful and on the *qui vive*. His world was fraught with religion. His was an excited spirit.

At no time in our history has the human "soul" asked so much of the artist as it did in the half century between 1815 and 1865, the years of our Romantic period. The country lived in a state of mind which depended to an unprecedented degree upon visual sustenance. The artist was presented with an extraordinary challenge: the imperative to produce the forms that would articulate the spirit of the age. It was a challenge that our painters, sculptors, architects, our craftsmen and designers accepted eagerly and boldly. After all, had art ever had a higher mission in America? Indeed, neither before nor since the Romantic period have American artists enjoyed an equal sense of community and purpose.

This exhibition focuses upon the response of the artist in America to that peculiar challenge. The exhibition has been conceived neither as a survey of art nor as a study of taste in the Romantic period. It has instead been organized around the thesis that there is throughout the period a common and coherent conceptual system that determines the approach to form. Most works of art created by the self-conscious artist or sophisticated artisan embody the operative principles of the system with surprising completeness. This is not to say, however, that the system accounts for every feature of every work of art executed in the period. There are both cosmopolitan and provincial artists and artisans who were either part way into or part way out of the system. A naive or folk artist might have been affected only superficially by it, but this is to be expected as their work is more perennial than period in character. On the other hand, a foreign-trained artist, attuned to up-to-date developments abroad, might be deliberately rejecting it. So, too, might a native independent by an act of will break free of it. But these are the exceptions that prove the system's rule.

And what is this ruling conceptual system? Its basis resides in the instinct to make all form a language of human emotion. The instinct is itself part and parcel of the pantheist faith that all visible phenomena, tangible and intangible, are imbued with spirit. Spirit manifested itself in individual character and beauty, in attributes of association and symbol, in quality of action. All may be subsumed within the term "expression" as the term came to be used in the nineteenth century. One of

the fundamental categories of academic art theory, expression, had been codified long before the Romantic period. As early as the seventeenth century the Frenchman Charles LeBrun had reduced the concept to a formula. The eighteenth century, the century that invented the word "psychology," began to explore gradations in expression in ever more subtle terms, not only in its human guises, but also in animals and in unconscious forms. Stairs and towers, trees and mountains were perceived as inanimate actors. Sunsets and storms were portrayed as atmospheric moods and dramas. The Romantic artists of Europe were, in turn, to expand the range of expressive effects and to intensify the emotions.

WASHINGTON ALLSTON AND THE BEGINNING OF AMERICAN ROMANTIC ART

Benjamin West was perhaps the first American to catch the Romantic spirit. His work, however, belongs to the story of English art. American Romantic art begins not with him, but with those younger compatriots who were inspired by him in the early years of the new century. One of them, Samuel F. B. Morse, is not represented in this exhibition, though his work certainly fits into the theme. But the principal heir to the Romantic Benjamin West is Washington Allston. As it is he who espoused Romanticism as a young man and in the high tide of his powers introduced the new spirit full-blown on American soil, Allston has been assigned a special role in the exhibition.

Allston returned to America for the last time in 1818, just at the dawn of Romantic art in his native land. With him he brought a large canvas measuring some twelve by sixteen feet, a painting that was to be the masterpiece of his career—so he then hoped. The tragic and well-known story of that work, *The Feast of Belshazzar,* need not be repeated in detail here. That he never finished it is all that need be said. Still, *The Feast of Belshazzar* is a very important and, more than that, a very revealing work of art. It is a kind of *summa* of the Romantic artist's method, a sort of pictorial proving ground for much that was to follow. In countless ways its method was to be reflected in the work of younger American artists, not only painters, but also sculptors and architects, and even, in a sense, those who designed chairs, or stoves, or styles of lettering. Though it failed as a work of art, *The Feast of Belshazzar* represents a heroic effort to come to grips with the emotive potentials of art. In that painting Allston attacked a host of complicated problems of form and color, light and shade, invention and composition, action and expression. Allston declared his enthusiasm for the subject in a letter to Washington Irving: "I know not any that so happily unites the magnificent and the awful. A mighty sovereign surrounded by his whole court, intoxicated with his own state, in the midst of his revellings, palsied in a moment under the spell of a preternatural hand suddenly tracing his doom on the wall before him."

Let us examine an oil on cardboard study {pl. 3} for the ill-fated painting which itself now hangs in the Detroit Institute of Arts. The painting portrays the court of the Babylonian king Belshazzer at the very moment that Daniel interprets the mysterious handwriting on the wall. The setting is deliberately intended to suggest the heathen character of the nation that is enemy to the Jews. The columns are squat and ill-proportioned, the elephant-headed throne is hardly an object of beauty, the minorah with its globed, fat-legged stand is positively grotesque, the gilded coiled serpent is the very symbol of evil. Such forms obviously testify to the spiritual deficiency of the pagan people who created them. Actually, of course, these features are probably more Allston's invention than archaeological reconstruction. We shall see artists deliberately departing from classical norms: sometimes as did the architect A. J. Davis, because such norms were not sufficiently expressive; other times as did the painter John Quidor, because grotesque props were demanded by the subject.

The vessels in the immediate foreground of *The Feast of Belshazzar* could actually have been fashioned by Greek hands. Allston has employed them less to introduce some objects of beauty as foils to Babylonian taste than as reinforcements to the spirit of the scene. One has been knocked over. It is perhaps a metaphor of the impact of Daniel's prophecy of doom. Another vessel is quite stubby, a third, rather attenuated. The latter two appear to embody the actions of the two nearest figures: the recoil and cringe of the king, whose heart, said

Allston, is "compressed," and the rise and address of the "less guilty but scarcely less agitated" queen. Later we shall see how William Sidney Mount would exploit, in a very similar way, the implicit expressive movements of farm tools. In the applied arts, too, commonplace objects like chairs and stoves were destined in time to be conceived as emotive amenities.

The movement of the figures in the entire scene is highly dramatic, an order of movement that our genre painters would emulate as they discovered comparably dramatic subjects in everyday American life. Even architects and landscape painters like Richard Upjohn and Frederic Church were to produce compositions endowed with analogous essences of movement.

In the case of Allston, the source of inspiration for such an arrangement of figures ultimately harks back to one of his favored models, Raphael. Closer at hand would be the example of West, who comes to mind especially in view of the patently eclectic nature of *The Feast of Belshazzar*. The sumptuous setting with its ornate furnishings, expansive tables and parade of architecture recalls Veronese, while the chiaroscuro, with its bold oppositions of deep shadows and dazzling light, points both to Tintoretto and to Rembrandt. There are hints of the latter, too, in the detailing of the jeweled gowns of the court attendants. Eclecticism in painting, in architecture, in furniture, pervades much of our Romantic art.

No less significant than the aspects of Allston's painting already discussed is the fascination with pose and facial expression in individual figures. Indeed, one suspects that the painter's primary interest was to explore as wide a range as possible of the complexities of reaction to a supernatural event. Absorbed as he was with the divine, from the diabolical to the holy, Allston could hardly have found a passage from the Bible of superior pictorial richness: the retinue of an ancient Eastern royal court, pagan-souled high priests and soothsayers, a ruler only now learning to play his role, his worldly-wise mother, and captives of the Lord's people, chief among them one of their greatest prophets. The psychology of every face and figure, save for those which are lost in shadow, is a spiritual portrait or was intended as such. Indeed, the intention was Allston's dilemma in such depictions of the terrible

and the mysterious. It was an ambitious but a futile endeavor to compete with another art: literature. Seeking desperately to say the last word about each character, Allston at moments came dangerously close to producing caricature. Certainly this is the case with the soothsayers and high priests. The king and the queen might almost be engaged in pantomime. The gesture of Daniel's hand seems melodramatic; his face strives too hard to reflect the fire of divine inspiration; his body, though monumental, lacks adequate interest for its central position in the composition. The major purpose for this analysis of the figures, however, is to call attention, not so much to the picture's shortcomings as to the fact that the painter was striving to attain to new and unprecedented refinements in the representation of the spiritual. The picture is a perfect document of the inextinguishable Romantic urge to reach beyond the purely earthly and material.

"Soul" and "spirit" are words that punctuate Allston's thoughts. They appear repeatedly in his writings. They are words which run through our Romantic decades like a refrain: in the journals of William Sidney Mount and Thomas Cole, in *The Portfolio* of elevating ideas collected and published by Rembrandt Peale, in the comments of Frederic Church's critics, in the architectural writings of Andrew Jackson Downing, in the inspired utterances of the Shakers, and so on. Allston's *The Feast of Belshazzar* reveals the Romantic mind on the alert for every visible, and more than visible, nicety of the transcendent. "There [is] scarcely an object in Nature," Allston wrote, "which the spirit of man has not, as it were, impressed with sympathy, and linked with his being."

In his search for the manifestations of spirit Allston produced better pictures when he portrayed a mood rather than a drama. No lines catch the essence of his *The Evening Hymn* {pl. 7} better than those of Oliver Wendell Holmes:

We are more pleased with such [paintings] as the 'Evening Hymn' and the 'Spanish Maid.' In the first of these just mentioned, for instance, the effect of the 'dim religious light,' which blends softly together the hard outlines of day; the character of the architecture, of which just enough is seen; the mellow shadows, in the clear depths of which a strong light will reveal new objects to the spectator; the character of holy repose,

[3]

that spreads, as if from the maiden's soul, to her features and her figure, and outwardly into all the inanimate things around her; produce upon us an influence which proves the power of these harmonious combinations in suggesting images hardly to be directly delineated. (*North American Review*, April, 1840)

It was in the imagery of calm and reverie that Allston most consistently succeeded. In *The Evening Hymn* he could express himself without strain and hyperbole. There is no need to know the Old Testament or any other written source. It is not an illustration. It is a poem without words, a song without sound. The picture is an emanation of Allston's soul, a Venetian lyric distilled of any sensuousness by the purity of mind of an American Transcendentalist.

The laws of matter seem to have been suspended in *The Evening Hymn*. There is no sense of substance or body. For Allston, art was a means of deliverance from man's carnal nature. This Puritan impulse, the impulse to slough off the body, was noted by D. H. Lawrence as basic to our classic literature of the nineteenth century. He might just as well have been speaking of our visual arts. Our architects were repelled by the Baroque, attracted by the Gothic. The Baroque swooned, the Gothic soared. The one was sensuous, the other spiritual. The Gothic style answered almost miraculously to the urge to slough off the body. So, too, might landscape answer to the same urge as American painters sought in nature a release from the cares of the flesh or the recovery of Adamic innocence. In their own peculiar way the Shakers, too, were to deny the body as they fashioned an aesthetic of asceticism.

There is little evidence even in Allston's studies from life that he took heed of the body as an organism. His interest was in the demonstrative aspects of separate parts of the body, so basic was his concern with matters of the spirit. He would focus his attention particularly on heads and hands. They were, he said, the two most expressive features of the body. A splendid oil study of the head of a Jew ⊰pl. 14⊱ implicitly reveals his primary concern with spirituality. Doubtless executed in London when Allston was preparing to paint *The Feast of Belshazzar,* the countenance of this man, stamped with the awe of a believer, could readily have been adapted to any of several faces that appear in the Biblical scene ⊰pl. 3⊱. A study in pencil captures a hint of wonder in a somewhat less inspiring face ⊰pl. 17⊱ that would have required only the addition of a beard to serve for one of the heads in the right-hand background behind the priests and soothsayers. Suggestive of benevolent encounter with the divine, though apparently not a study that relates immediately to *The Feast of Belshazzar,* is the woman's face also reproduced in plate 17.

Allston's alertness to every gradient of expression is revealed no less tellingly in four studies of hands which may be examined on a scale ranging from perfect repose to extreme tension. The most relaxed of the group is the study of a hand ⊰pl. 5⊱, presumably a woman's, that would have harmonized easily with the mood of *The Evening Hymn* ⊰pl. 7⊱. Equally at rest, perhaps, but slightly more animated in its contours, is the hand studied in no. 10 ⊰pl. 25⊱. The reference to its quality of contour raises a significant point about the Romantic attitude towards form. It was the movement of the surface, not the structure underneath, that was of primary interest, for it was the movement of the surface that produced the emotive effect. Although the hairless male hand was a convention of Neoclassical art, it also brings to mind the example of Michelangelo. The exemplar, in Allston's mind, of transcendence in art, the sixteenth-century master of the sublime exerted a profound influence on his Romantic follower four centuries later. The other hand in plate 25 (no. 9), imbued as it is with a greater sense of latent strength, is particularly Michelangelesque. It suggests a state often remarked in the work of art in the 1800's: power in repose. Endowed with that same power, but by no means in a state of repose, is the clutching hand reproduced in plate 5. A study for the left hand of Belshazzar, it recalls Allston's observation that the hand rather than the face, was the true key to the mind of its owner. The strained lines, taut planes, and harsh oppositions of light and shade render this hand an index to the expression of the entire figure of the king in the painting ⊰pl. 3⊱. Allston saw to it that every feature of the work of art contributed to the expression of the whole. This, too, is a principle that Romantic artists consistently observed.

It would have been customary in the Romantic period to apply the term "gradation" to the continuum of expression indicated in these last four drawings. It is a concept that will be illustrated any number of times in works to be considered further along in this discussion. One artist who was adept in the Alpha and Omega of gradation as he applied it to the American scene was George Caleb Bingham. Although Bingham was very attentive to heads and hands, the focus of his drawings was on the whole figure, or, often, a pair of figures. Three drawings of pairs of figures constitute a nativist down-to-earth parallel to the Allston drawings just considered. As Allston tended to accent the expressive, so too does Bingham, but he does it simultaneously in every visible aspect of the figure, from shoe-sole to hat-crown. The gradient in these three drawings begins with the alcoholic relaxation of the drooping drunk whose form almost blots out the more energetic companion who supports him {pl. 4}. There is a sense of animation and alertness personified in the pair of citizens who are engaged intently in a political dialogue {pl. 1}. As hands proceed from limp to active in these first two drawings, there is an intensification of the drama of these yeoman-voter vignettes. In the third drawing there is still a further intensification of the dramatic as the contrast between the two figures decisively widens: as one becomes the attentive, agreeing listener, and the other the forceful, over-powering speaker {pl. 4}. The latter's body is massive and simple. Its energy seems to be concentrated into the aggressive thrusts of his hand, chin, nose, and hat-brim. Bingham's method was in essence the same as Allston's, although its spiritual content was limited to the realities of the egalitarian soul. Bingham, like Allston, edited his studies as he introduced them into his group scenes on canvas. The speaker in the last drawing, for example, appears to have lost some force as he was incorporated into *The County Election* {pl. 26}.

This spectacle by George Caleb Bingham of the operations of democracy on the frontier represents a translation of Allston's universalism into the actualities of mid-century life. The coordination of the movement of the individual figures is as Raphaelesque as is Allston's in *The Feast of Bel-shazzar* {pl. 3}. In that scene of supernatural intervention the movement is given impetus by the figures of the king and queen and resolved, supposedly, by Daniel's firm, upright stance (which Greenough the sculptor compared to a lighthouse) and imperious gesture. Much less terse and divergent is the anarchistic, sprawling, exuberant movement of Bingham's exhibition of the launching of democratic institutions in the Promised Land of the West. In *The County Election* the movement starts out with Jacksonian casualness on the left, gradually to gain momentum and surge like a wave of American energy up the steps of the dignified courthouse, only a moment later to break and crash down on the slumping back of a dazed and dejected drunken citizen. In the distance there is the confusion of bounding forms defined by trees, buildings, horse and rider, and signpost. In the foreground there is the order of a majestically rising classic portico built of plain boards by Missouri carpenters. These features conspire to do in their way what vases, throne, minorah, and columns did to characterize the Babylonian court. The entire scene—its setting and its people—proclaims the stability, vitality and expansion, the simple plebeian grandeur of the raw and powerful new republic. *The County Election* is a window opening onto the excited spirit of the America of 1851.

Only one other artist of the mid-century adapted the Grand Style to the life about him as successfully as did Bingham. This was William Sidney Mount. With Allston, Mount shared an admiration for both Raphael and Rembrandt and a fascination with "spirit" and "expression." Mount's *Banjo Player* {pl. 6} is virtually a transposition of Allston's *The Evening Hymn* {pl. 7} into the actualities of the farm. The suggestion of the player keeping time with his foot and the tradition that two dancing figures were once visible in chalk against the unfinished hay in the center indicate a higher level of animation than Allston's weightless daydream, but the mood is still pensive. As a shape, the banjo is as quiet as is its counterpart in *The Evening Hymn*, the lute, and the setting is almost as soft and gentle. Mount's unpresuming sophistication reveals itself felicitously in the subdued forms of the barn. One need only compare the planks, rafters, posts and beams, knots and nicks of this

quiet scene with their counterparts in the noisy scene presented in *The Dance of the Haymakers* {pl. 2} to realize how skillfully and deliberately Mount orchestrated his wood. He was depicting this tractable substance—thick or thin, boldly projecting or rounded off, highlighted sharply or muted in shade, in densely concentrated heavy elements or in openly and sparsely disposed elements—essentially as the architect A. J. Davis would orchestrate stone. It is significant that the painter in his notebook quoted Ruskin's words: "Every architect ought to be an artist; every great artist is necessarily an architect." In Mount's hands, boards become an emotive language. He was not an abstracting realist like Homer, portraying objectively the structure before his eyes {pl. 93}. He was an editing realist, inventing barns that structured his feelings.

As the *Banjo Player* lends itself to comparison with Allston's *The Evening Hymn,* so does *The Dance of the Haymakers* lend itself to comparison with Allston's *Study for the Feast of Belshazzar* {pls. 2 and 3}. There is, of course, gaiety rather than anxiety in Mount's painting, but the dramatic means are analogous. Faces and poses, composition and chiaroscuro, color and form have been conceived similarly. The tensed compression of the left third of the Biblical scene has in the right third of the barn scene given way to exuberant expansion. Where pitcher and vase embodied a spirit of dismay and alarm, pitchfork and rake now embody a spirit of spontaneity and joy. With Yankee wit

Mount makes a platter of ham spiral and pirouette and the tines of a hayfork bound in sympathy with the nearby dancer.

The violin was the instrument dearest to Mount's soul. He admonished himself to "give expression with the bow." Reportedly, there was in the Mount family a tradition that a fiddle would burst apart whenever a member of the family died. It is a tradition that would accord with one of William Sidney's enthusiasms: spiritualism. The instrument in this scene of life seems, indeed, also to explode as its lively contours conform to the spirit of the moment.

Mount, like Allston, was a master of expressive form, perhaps so much so that he served as a model for other artists. Certainly, in the use of paddle, gun, and punt, William Ranney's *Duck Hunter's* {pl. 70} calls Mount to mind. Here, the tension implied in these forms—most of all that of the stretched out craft—comprises a visual metaphor to the precise timing and eager expectancy of the moment. Even the water (with its thin, wire-tight ripples) and the land and the clouds assume a tautness that vibrates in sympathy with the shrill, strained silence that will shortly be broken by the crack of the rifle. Compressed below the horizon line, figures and objects compose a knot of barely restrained energy, poised for imminent release. If the mood of *The Dance of the Haymakers* is one of explosive gaiety, the mood of *Duck Hunters* is one of hushed and breathless suspense.

GRADATIONS OF EXPRESSION: THE HEAD, THE BODY, AND THE SOUL

So far we have considered expression primarily in the characters and in the inanimate features of history and genre paintings. Expression, however, was of central concern not only in the representation of types, but also in the representation of specific persons. With so much interest in the revelation of the spiritual in the individual, it was inevitable that any hint of the soul in the face or in the body would be seized upon by the artist. A literally dramatic example would be Henry Inman's portrait of the English actor William Macready {pl. 13}. It supposedly depicts the subject as William Tell, one of the few non-Shakespearean roles associated with this great visitor to the American

stage. Tousled hair and rushing folds of a nondescript costume are obvious emotional flourishes. To twentieth-century eyes the face seems overanimated. But refinement in gradations of expression was just what Romantic audiences wanted. We can marvel today that Philip Hone, one-time Mayor of New York, could devote pages of his diary to the critical appreciation of Macready's theatrical performances.

Actors of another sort, statesmen-politicians, also figure in that same diary. One of them, John Calhoun, was a villain to Hone but an inspired leader to Rembrandt Peale {pl. 14}. Alongside Fenderich's matter-of-fact lithograph of the hard-bitten

champion of states' rights as he appeared in 1837 ⊰pl. 14⊱, Peale's portrait dating from the following year taxes the viewer's credulity. In the canvas Calhoun's features are serene and sensuous, his gaze is that of a poet or visionary. Almost a *leitmotiv* in *The Portfolio* of selected quotations which Peale published in 1839 is the theme that the portrait must capture the "soul" or "spirit" of the subject. Conscious of his responsibility the painter bestowed upon the eyes of the South Carolinian that same sense of divinity, that "beam of Heaven" (to quote *The Portfolio*), that marks the face of the Jew sketched by Allston some twenty years before ⊰pl. 14⊱.

It is amusing to us today to see how such arch-enemies in *ante bellum* America as John Calhoun and Daniel Webster could both be regarded as mysteriously favored by God. In his portrait of "the defender of the Constitution" ⊰pl. 15⊱, G. P. A. Healy presents the New England Puritan with features as stern and unsensuous as granite. Appearing to receive his instructions from on high, the nineteenth-century statesman might just as well be one of ancient Israel's inspired leaders. Indeed, there was a "story that used to run that the great Daniel of today was to be represented in the Prophet" of *The Feast of Belshazzar.* So we read in an early biography of Allston.[1] As an orator Webster stood second to none on the political stage. He matched his verbal gestures and postures with the movements of his body and the expression of his face. Francis Alexander seized the Webster of an impassioned moment ⊰pl. 12⊱. We are reminded of Macready as William Tell, or even of Napoleon as David imagined him on the Alps. Add a hand pointing at the spectator and Alexander's *Daniel Webster* would do as Uncle Sam on a recruiting poster.

A more pedestrian version of the Massachusetts statesman is the bust of him by Hiram Powers ⊰p. 12⊱, the sculptor who regarded sculpting as a "mechanical art." Actually Powers placed his faith unreservedly in the exact particulars of a purposeful nature. To him there was nothing accidental or haphazard about a man's features, for "the face," he said, "is the true index of the soul, where everything is written had we the wisdom to read it."

Although Powers appears to have concerned himself only casually with the great pseudo-science of self-improvement, phrenology, his subject had been favored, according to enthusiasts, with one of the finest heads of the era. Few could match Webster's superlatively formed cranium. One may compare the famous brow bump by bump with charted counterparts on the phrenological model reproduced in plate 13. The attributes of spirituality (faith, trust and wonder), of ideality (expansiveness, refinement and perfection), and of imitation (adaptiveness, gesture and copying), are among Webster's cranial *fortes*. A comparison of the daguerreotype profile of the statesman with a Bennington graniteware phrenological head calls attention to his high dome, the mark of "benevolence" ⊰pl. 29⊱. In his *Hereditary Descent* Orson Fowler noted that this was a well-defined and persistent bump in the Webster family. In their case it was a virtue that had been developed almost to the extent of being a liability. The Websters were too generous with their money. Before the age of psychiatry, it was Providence and willpower that got people's heads together. Orson Fowler and his brother Lorenzo, in their popularized versions of phrenology, assured the reader that he could take corrective measures to improve himself if he happened to rate low on those bumps where, intellectually and morally, he would like to rate high. With so many people— among them Melville, Poe, and Whitman, Cole's biographer Louis Noble, and the painter William Sidney Mount, to name a few—examining head shapes and with so much emphasis on "spirituality," it is small wonder that portraits were important in moral, Protestant, individualistic mid-nineteenth century America.[2] In the engraving after Rothermel's *United States Senate* ⊰pl. 27⊱ the eye fixes on one emphatically unique head after another. The bodies seem to be merely appendages.

Still, body action as it revealed character or expressed emotion could be considered worthy of notice. Pose and gesture, hair and clothing, as well as facial expression, were of signal importance in

[1] William Ware, *Lectures on the Works and Genius of Washington Allston* (Boston, 1852), p. 129. The text adds the sad reflection: "But there was no such good fortune in store for us."

[2] According to an early biography of Mount, the painter's "phrenological hobby" was apparent in "the musical bump of the negro" in *The Power of Music* (New York, Century Association, 1847). The "organ of tune" was "much developed" in this head. It is the same black man who appears in *California News* ⊰pl. 22⊱. See W. A. Jones in *The American Review,* XIV (August, 1851), p. 125.

historical and genre art ⟨pls. 2, 3, and 26⟩. They were also important in the painted, sculpted, or photographed portrait, or in a scene of the Senate in action ⟨pls. 11, 10, 29, 34, and 27⟩. Ultimately it was classical ideals of antiquity and the Renaissance that provided the models for bodily deportment, the set of the hair, and the folds of the drapery. Every self-conscious artist of the day, if he had not seen them in Rome, would have known such celebrated paradigms of art as Raphael's *Transfiguration* or the *Apollo Belvedere* through an engraving or photograph, a copy or a cast ⟨pls. 16 and 10⟩. Church, as we shall see further on, could apply the lessons of both to the depiction of landscape, as did his teacher Thomas Cole, who had exclaimed before the *Transfiguration:* "Expression is the soul of this picture." Washington Allston compared the *Apollo* to a visitor from another world, "one who had just lighted on the earth, and with a step so ethereal would the next instant vault into the air." Knowing this, we are not surprised to discover the *Apollo Belvedere* in the guise of heavenly deliverer in Allston's sketch of the angel releasing Peter from prison ⟨pl. 43⟩.

An assiduous student of pose and drapery, George Caleb Bingham translated the classical prototypes into the contemporary world of Missouri. His mastery of "expression" has already been noted in some of his studies ⟨pls. 1 and 4⟩. Bingham of course did not limit himself to Raphaelesque heroics as he accommodated history painting to such mundane realities as the effects of hard cider on his fellow-countrymen. In his drawing, the *Hearty Drinker* ⟨pl. 10⟩, for example, the folds of the trousers and the brim of the hat suggest the beverage's relaxing influence, while the creases of the sleeves and vest almost seem to smile or laugh. Another drawing records a more advanced stage of the beverage's influence ⟨pl. 19⟩. Here instead of gaiety, the pose, the clothes, and the hair, in their lifeless droop, epitomize alcoholic stupor. Even within the restriction of the camera, the photographers Southworth and Hawes exercised extreme care as to props and pose, expression of the hands and face, set of clothing and hair. All these concerns are reflected in their splendid portrait of the great New England shipbuilder, Donald McKay ⟨pl. 10⟩. The carefully shaped head of hair surprisingly recalls the *Apollo* ⟨pl. 10⟩. Yet this is not to

say that any conscious allusion was intended. The tradition of Greece and Rome was brought to bear on the moral characterization of the statesman, the clergyman, the businessman and the anonymous citizen. Through books, engravings and photographs, popular magazines, and annuals the mind of the mid-century had been conditioned, without even knowing it, to perceive *à la* the *Transfiguration* and the *Apollo Belvedere*. The Grand Style, in short, had become second nature.

Only at the end of the Romantic period did the classical heritage begin to break down. One radically new and fresh alternative, one which attracted William Morris Hunt and Winslow Homer, to mention artists represented in the exhibition, was the Japanese print. Another alternative to the Greco-Roman tradition was science and that instrument of science, the photograph. Eakins is the primary example. His photographs contrast strikingly with those of Southworth and Hawes, or, for that matter, with the drawings of Bingham. Eakins' father-in-law William MacDowell ⟨pl. 10⟩ appears to assume a pose that is natural to him. The old hat and jacket are not props intended to suggest gaiety or dignity, gentleness or force of character. They are, instead, records of the movements of MacDowell's body, movements which tell of the man as a physical being, existing in finite time. The portrait in plate 15 undoubtedly draws upon the painter's photographs of the same sitter. To contrast Eakins' *William H. MacDowell* with Peale's *John Calhoun* ⟨pl. 14⟩ is to witness a revolution in the concept of portraiture. In the earlier work smooth contours idealize the face with a classical beauty; in the later, eroded contours scrupulously record the life of mortal flesh. Eakins sought to reveal not the "soul," but the "experience" of his subject.

What a sudden departure Eakins represents from the mid-century fascination with distinctions of feeling and states of consciousness! Examine (to choose the work of just one artist) a random sampling of Mount's drawings. In the faces alone one encounters an extraordinary range of distinctions, all the way from death, in the eternal sleep of his brother Henry, to intense excitement in the study of the actor Kean ⟨pl. 18⟩. Living in a period that admired Hogarth's genius for nuances of expression, Mount inevitably would have been at-

[8]

tracted to England's great pictorial satirist ◄pl. 16►. On one page alone he copied the features of gluttony, fright, skepticism, and a dozen other characteristics noted by Hogarth a century before. The repertory of expressions in *California News* ◄pl. 22► demonstrates how Mount sharpened his eye for psychological perception, as a gamut of reactions to reports of gold is delineated in a roomful of faces of all ages. Most register enthusiasm, but the silent witness in the photograph on the wall appears to be holding back as he folds his arms and stares, perhaps in judgment, upon the scene. And Mount himself, supposedly the man with the pipe, we know was thinking: "I hope it may turn out a blessing to the country [rather] than a curse."

Bingham, as we have observed, perceived gradations of expression less in terms of smiles and frowns than in terms of the whole figure. Hence his drawings focus not so much on the heads as on stance, gesture, and costume. The head-to-toe categorization of degrees of inebriation in the studies for *The County Election* reflects in one character

type alone the acuity of Bingham's observation. The painting itself, which includes almost sixty figures, reads like an inventory of expressive characters ◄pl. 26►.

Any moderately sophisticated artist of the period would have formed the habit of examining the state of mind of his subject and would, indeed, have sought to articulate its every nuance. Sully's fancy must have delighted in the detection of each wisp and breath that told of a sleeping child's unconscious innocence ◄pl. 19►. And he would have admired Henry Inman's alertness to every sign of nerve and soul contrived by such a master of expression as the actor William Macready ◄pl. 13►. Collaborating with the architectural painter Charles Rosenberg, James Cafferty catalogued an array of emotional responses on the faces of Commodore Vanderbilt (the short man with sideburns at the extreme right) and scores of would-be Vanderbilts who swarmed into Wall Street as bank after bank closed its doors that bleak Tuesday, October 13, 1857 ◄pl. 21►.

IMAGES OF MANIFEST DESTINY

Whereas Allston never portrayed drama in terms of the here and now, his successors, Mount, Bingham, Messrs. Cafferty and Rosenberg, and countless others, found drama everywhere about them. In the excited days of Manifest Destiny, American life *was* drama. Thus the engraving after Rothermel's *United States Senate* commemorates one of the trying political ordeals of the expanding new republic: the debate which concluded in the Compromise of 1850 ◄pl. 27►. Henry Clay introduces the fateful proposal for compromise as his enemy Calhoun and his ally Webster listen. At that same moment, a thousand miles to the west, Missourians were learning—a little shakily, it would seem—to exercise the rights of a free people; so Bingham's *The County Election* ◄pl. 26► attests. Still further west, on the plains, more adventurous citizens were risking, as Wimar's *The Attack on an Emigrant Train* ◄pl. 20► luridly reports, the dangers of seeking a new life in California.

Mount's *California News* ◄pl. 22► advertises another reason and another way to go west: the discovery of gold and the sail around the Cape.

The painter once autographed a poster proclaiming "the American institutions and the American spirit, if not the American flag, must rule over Central America." Still, despite his endorsement of this patriotic manifesto, Mount was willing to direct his wit at some of the seamier aspects of American expansionism. Over the post office door in *California News* hangs a painting of greedy hogs, a silent gibe at the spirit that induced not a few of Mount's Long Island neighbors to abandon family and farm. It was that same lust for money, and the power that money brings, that, in the panic of 1857, convulsed the worldly spirit of the dollar-minded ◄pl. 21►. We today may wonder whether, in the excitement and turmoil of the moment, those bankers and brokers saw the irony in that gesture of an otherworldly spirit which presides so disdainfully over the scene: the soaring tower of Trinity Church. How the painters must have relished the contrast of God and Mammon!

The urge to Empire was actually believed to be both materially and divinely inspired. Nature, according to the mythology of Manifest Destiny, had, in God's mysterious way, issued the command

to the new nation to spread its domain across the continent and its influence around the world. It was a time to think big, to think globally. Donald McKay, the Massachusetts shipbuilder (at rather too great a cost to himself, it turned out), responded to the cosmic urge as he designed and constructed the largest ship yet known in history, the *Great Republic* ⊲pls. 23 and 25⊳. Launched in Boston in October of 1853, this 4,555-ton clipper, measuring 335 feet in length, with one of her masts reaching up 131 feet, burned to the waterline in New York less than three months later.

Despite panics and fires, however, the spirit of expansion continued to inspire Americans. It led Frederic Edwin Church, in the summer of 1859, far to the north where he chased both Arctic icebergs and Arctic curve. The chromolithograph after the painting which resulted from the trip intimates that Church had more in mind than just the satisfaction of scientific curiosity ⊲pl. 24⊳. In the foreground a derelict fragment of mast with crow's nest forms a cross to suggest an Arctic martyrdom, perhaps the tragic fate of the Franklin party. This not-so-accidental cross points to a natural bridge which forms the gateway to a vast waterway that reaches past the earth's horizon, groping for the Pole. The vista has just at this moment been revealed, as a curtain of clouds draws back from the scene. Great, glorious Titans of ice swell and surge in a paroxysm of energy. The excited spectator all at once becomes witness to one of the globe's great revelations: the opening of the Northwest Passage. The myth of America as the meeting of East and West, the same myth celebrated also by the poet Whitman, unfolds before his very eyes.[3] The picture is a cosmic icon.

Those of us living in an age of not-so-Manifest Destiny would perhaps just as soon not see our myths bared so dramatically. But in those yesteryears of confidence our ancestors were ever ready to place faith in those dual and mutually reinforcing sources of revelation: science and the Bible. Thus the Arctic might promise the Millennium; the Senate could harbor the modern-day Daniel.

ART AND "THE GREATEST MAN THAT EVER LIVED"

If our ancestors could look upon Webster as a prophet, Washington had to be nothing less than a demigod. He had hardly departed this earth when, as an engraving of 1802 makes almost comically visible to us, his survivors proceeded to apotheosize him ⊲pl. 30⊳. At the turn of the nineteenth century, Americans were already picturing their own peculiar New World revelation. How startlingly reminiscent of Raphael's *Transfiguration* ⊲pl. 16⊳ Barralet's print is! While he was living, Washington had seemed too human to be more than the greatest man of the age. Gilbert Stuart first caught in the Athenaeum portrait and then went on to repeat dozens of times for the next thirty odd years this human Washington ⊲pl. 30⊳. As the memory of the real Washington faded into history, and as the new nation began to discover the glorious destiny that Providence had assigned it, the "Father of His Country" acquired an almost superhuman identity. In the version of the "porthole" portrait illustrated here ⊲pl. 31⊳, Rembrandt Peale, who had as a youth of seventeen painted the first President, proposed the identity of Washington with Zeus. The god's face is supposedly depicted in the mask, but protrusions on the forehead suggestive of horns encourage the speculation that an allusion to Moses may also have been intended. At least one of Rembrandt Peale's contemporaries, Hollis Read, the author of a book entitled *The Hand of God in History,* associated Israel's great leader with America's leader, and, indeed, rather condescendingly at that: "Moses was the George Washington of the Jewish Commonwealth."

Still loftier as a conception of *Pater Patriae*— one, sadly, that proved so lofty that it was for a time relegated by an ungrateful public to a warehouse—was Horatio Greenough's eleven-foot-high

[3] It is this same myth that Church celebrated at his residence, "Olana," where he combined, or rather synthesized, the traditions of East and West through the imaginative arrangement of *objets d'art* and the adaptation of European and Oriental styles of architecture and decoration. The property itself would have been seen first by the white man when Sir Hendrick Hudson in 1609 sailed up the river that now bears the navigator's name. His quest then was the discovery of the Passage to India, that passage which became a visual rite at "Olana" two and a half centuries later. See my *The Landscapes of Frederic Edwin Church: Vision of an American Era* (New York, 1966), Chapter VIII.

statue which presents Washington as Zeus enthroned and nude to the waist. Originally intended for the Capitol Rotunda, the sculpture now dominates a stairwell at the Smithsonian's Museum of History and Technology. The drama intended by Greenough cannot be duplicated in this setting, but the *Washington* can at least be seen to good advantage. Greenough adapted the motif of the seated god, but only after he had considered a number of alternatives, one of which is illustrated in plate 34. Togaed and standing beside a rostrum-like pedestal this pose is less suggestive of a god than of a statesman. Drawings by the sculptor of Washington's head serve to illustrate the very process by which an artist sought to invest an actual human being with the quality of the spiritual. A comparison of two profiles ⊰pl. 28⊱ suggests that Greenough deliberately sought to "open and loosen" the hair in order to spare his subject the "weak and mean look" of a "smooth head." In the same two drawings he was apparently also seeking a balance between the character of an aged, and the glamor of a youthful George Washington. A drawing of 1827 ⊰pl. 30⊱ informs us that Greenough studied a version (presumably the original one) of Stuart's Athenaeum portrait some five years before he received the commission for a statue of Washington from Congress. When he actually began work on the commission in Florence, Greenough had Francis Alexander paint a copy of the *Athenaeum Washington.* The sculptor's primary model, however, was not Stuart's painting. The commission from Congress had prescribed Houdon's portrait bust of Washington as the type. It was from a cast after Houdon's original that Greenough drew the profile of Washington illustrated in plate 32. The emphasis upon straightish lines and decisive angles hints at some editorializing on Greenough's part. There is more force of character here than in Rogers' softer-edged copy after Houdon ⊰pl. 32⊱. Greenough was seeking in this angular profile that same quality of form that Rembrandt Peale in his textbook, *Graphics,* associated with "energy" and "character" ⊰pl. 61⊱. Thus in his design for the statue's pedestal ⊰pl. 34⊱, Greenough was careful to project insistent straight lines and decisive angles.

Greenough's approach to the idealization of the body was rooted in Neoclassicism. A fifth-century Greek prototype such as the Borghese Mars provided him with an archetype of masculine beauty and strength. He had already studied this sculpture at the very outset of his career ⊰pl. 35⊱. In turn the live nude model drawn at the Academy in Florence several years later ⊰pl. 35⊱ seems virtually a Mars-become-flesh. The next stage in the idealizing process would be the adaptation of qualities examined in these two studies to the sketch for a standing Washington ⊰pl. 34⊱. Eventually the escalation of idealization would lead to the Washington that too many practical Americans found too removed from reality. Greenough once wrote to Allston: "We should seek to ennoble our works by putting into them all that we can conceive to move the mind—all that's dear in beauty, all that's moving in passion, all that's grand in thought." His quest to embody the "spirit" of Washington may have ended in failure, but it was a heroic quest all the same.

It is fascinating to those of us living in an age of anti-heroes to observe the perceptions of an age of heroes. The idea of Washington was too protean to assume form only in human guise. Any form that seemed to embody qualities that characterized him might in turn be expressly identified with him. Predictably, his name was given to any number of ships, including the packet boat which appears in a scene of New York Harbor dating from the 1830's ⊰pl. 90⊱. And appropriately, the loftiest of the peaks in the Presidential Range, the almost ghostly presence that dominates Cole's "White Mountains," bears the name of Washington ⊰pl. 74⊱. In the animal kingdom the eagle was readily associated with the soaring spirit of the great man. On the frontispiece to his *Portrait Gallery of Distinguished Americans* William H. Brown juxtaposed the silhouette of America's first citizen with the most majestic of birds ⊰pl. 29⊱. On the banks of the Mississippi John James Audubon was so taken with the imperious presence of a new genus of eagle that he could only think of naming it "The Bird of Washington" ⊰pl. 33⊱.[4] Sensitive lest the designation might strike some as "preposterous and unfit," the artist explained himself:

[4] The painting in the exhibition, *The Eagle of Washington,* depicts the identical bird appearing in John James Audubon, *The Birds of America,* I (London, 1827–30), plate 11, above the title "The Bird of Washington." The plate in the publication, however, presents a somewhat less developed setting.

As it is indisputably the noblest bird of its genus that has yet been discovered in the United States, I trust I shall be allowed to honor it with the name of one yet nobler, who was the savior of his country, and whose name will ever be dear to it. To those who may be curious to know my reasons, I can only say that as the New World gave me birth and liberty, the great man who insured its independence is next to my heart. He had nobility of mind and a generosity of soul such as are seldom possessed. He was brave, so is the Eagle. Like it, too, he was the terror of his foes, and his fame, from pole to pole, resembles the majestic soarings of the mightiest of the feathered tribe. If America has reason to be proud of her Washington, so has she to be proud of her great Eagle. *(The Birds of North America)*

The striking affinities between the painted eagle and Greenough's sketch for a full-height Washington and his profile drawing after Houdon's *Washington* are alone justification for Audubon's reasoning {pls. 32 and 34}.

In the realm of abstract form such as architecture, the idea of Washington, as it had assumed shape in the mind of Robert Mills by 1846, was published for the purpose of generating public support for the erection of a great monument in the nation's capital {pl. 39}. Contrary to expectations, the lithograph, instead, generated a flurry of negative criticism. William Sidney Mount's reaction is worth quoting in full: "It looks like a hundred-legged bug running away with a pillar, or a bunch of candles hanging down, or a whitewash brush standing ready for some giant to take up by the handle and sweep the streets of the metropolis." Greenough observed that the uncanonical round Doric colonnade at the base denied visual support to the obelisk and criticized the apex as too blunt. The shaft would appear at once unfinished and top-heavy. Such criticisms doubtless influenced the final design, though the monument was completed long after Mills' and Greenough's deaths.

Greenough was well-qualified to give an opinion on Mills' design. In fact, the sculptor may have deserved more credit than any other person for the design of our first colossal obelisk, the Bunker Hill Monument. Rejecting the idea of a giant column, the form specified for the initial competition, he presented the model of an obelisk, arguing that it was "the most purely *monumental* form of structure." The obelisk was indeed an eloquently expressive form. It could symbolize cogently both the spirit of those brave heroes who fought that early battle of the American Revolution and the spirit of their destined commander-in-chief {pl. 41}. Placed above the Charles River on the site pictured in Trumbull's battlepiece {pl. 40}, the obelisk, contended Greenough, "says but one word, but speaks it loud. If I understand its voice, it says, Here! It says no more." Straight and firm, more than twice as high, and seemingly connecting heaven and earth, the obelisk placed by the Potomac would in its final form proclaim the memory of, to choose a quotation from the period, "the greatest man that ever lived in the tide of time" {pl. 39}.[5]

SYMBOLS, MAN-MADE AND NATURAL

The fact that the citizens of the United States were willing to raise the funds privately to create such monuments is itself an indication of the age's deeply felt need for symbols. The story of the Bunker Hill Monument is a representative study of the thought and effort that such a project might entail. The Bunker Hill Monument Association was formed in 1823. Subscriptions were solicited beginning in the following year. Early in 1825 the competition for the design was held, and by the spring the architect Solomon Willard had been appointed to erect the structure. On June 17, "the Nation's Guest," General Lafayette, laid the cornerstone while Daniel Webster delivered the dedi-catory address. When Karl Bodmer sketched the site in 1832 {pl. 39} work had come to a standstill for lack of funds. Building resumed briefly in the middle of the decade, only to be halted by the depression of 1837. It was only through the tireless, resourceful exertions of Boston ladies and their sisters throughout the United States that enough money was raised to carry the project forward to its completion. A popular and effective means of generating dollars and cents was the sale of glass cup-plates pressed with an inscription of the ladies'

[5] Alexander H. Everett, "Greenough's Statue of Washington," *United States Magazine and Democratic Review*, XIV (June, 1844), p. 621.

cause and an amusingly dwarfish image of the obelisk of their efforts. One example, reproduced in plate 40, appears to celebrate the successful conclusion to their campaign in 1841. Two years later, on June 17, President Tyler and his cabinet, a regiment of soldiers, and the citizens of Boston gathered at Bunker Hill to celebrate the completion of the monument. Addressing the crowd in the lithograph view by Nathaniel Currier {pl. 41} is New England's favorite son, Daniel Webster. No other orator would have been equal to the occasion. A kind of human obelisk himself, Webster found the language to match that 220-foot high piece of rhetoric in stone:

It is itself the orator of this occasion; it is not from my lips, it is not from any human lips, that that strain of eloquence is this day to flow, most competent to move and excite the vast multitudes around. The potent speaker stands motionless before them. It is a plain shaft. It bears no inscriptions, fronting the rising sun, from which the future antiquarian will wipe the dust. Nor does the rising sun cause tones of music to issue from its summit. But at the rising of the sun, and at the setting of the sun, in the blaze of noonday, and beneath the milder effulgence of lunar light, it looks, it speaks, it acts, to the full comprehension of every American mind, and the awakening of glowing enthusiasm in every American heart. . . . Its speech will be of patriotism and courage; of civil and religious liberty; of free government; of the moral improvement and elevation of mankind; and of the immortal memory of those who, with heroic devotion, have sacrificed their lives for their country.

Joseph Chandler caught the man who uttered these words quarried from a vocabulary of the stern, the steadfast, and the stirring {pl. 79}. In the sober act of dedicating an obelisk at a hallowed site, Webster produced his own verbal monument.

Everything and anything might, in the Romantic imagination, assume the stance or serve as the symbol of human feeling and thought. The common man naturally perceived the weeping willow as the stance of sorrow, the truncated tree, as the symbol of a life cut short {pl. 46}. In something so universal as death the naive artist did not need to be a poet or a philosopher to know the meaning of such forms. However, the naive artist might fail when he was confronted by an object that challenged inventiveness of imagination. Before the New World's "most suggestive scene," Niagara, the painter Thomas Chambers was unable to play the role of poet or philosopher {pl. 44}. What

Thomas Cole would portray as a scene to stir the emotions, and Frederic Edwin Church as a revelation of America's meaning, Chambers portrayed as a lively design that might decorate a tea tray. Niagara offered him a selection of darks and lights, warm and cool colors, a few distinctive shapes and lines that he might conventionalize, and a waterfall of a scale which he ingenuously minimized by introducing an overlarge figure and overlarge houses. Chambers produced an ornament that charms, but not a work of art of any depth of feeling or thought.

Before Cole's version {pl. 44} we immediately become aware of the artist's feelings. He revels in the height of the falls, in the breadth and depth of the landscape. His brush directly conveys his sense of excitement. Impulsive strokes of white pigment catch the thrill he feels at the sight of the rapids above the cataract. Contrast Cole's capriciously varied whitecaps with Chambers' predictable scalloped white line that schematizes the moving surface of the water. It is the difference between the poet's emotion and the ornamentalist's stylization.

While Cole might temporarily respond to the sublimity and beauty of Niagara, he found that it soon ceased to excite much emotion: "The mind quickly runs to the fountain of all its waters; the eye marks the process of its sinking decay." He viewed the great landmark ultimately in terms of his personal sense of frustration with life on earth. He preferred to look upon mountains: they promised release to his soul. With his pupil Church, on the other hand, Niagara was the very embodiment of America's variety and exhaustless energy {pl. 45}. The words of one of its first viewers speak eloquently for the painting:

If it is inspired by Niagara, it is grand and sublime; it is natural to the nation, since nature herself has given the type; it is wild and ungovernable, mad at times, but all power is mad at times. It is the effect of various causes; it is a true development of the American mind; the result of democracy, of individuality, of the expression of each, of the liberty allowed to all. (Adam Badeau, *The Vagabond*)

Identifying with his fellowmen in the here-and-now, Church saw Niagara through the age's collective eye and spirit. In his hands the personal, subjective brushstroke of his teacher, Cole, became impersonal and objective. Laws of force, rather than the artist's feelings, determine the motion of the water as Church seeks, not the reflection of his

[13]

own soul in nature, but the reflection of nature in his own soul.

Church was the very painter that Ralph Waldo Emerson had called for: "a transparent eyeball." The painter simply held the telescope to the interested eye, confronting that eye with the reality of Niagara. The spectator occupies the scene, looks down upon the water rushing past his feet, gazes forward to the horizon stretching across his line of vision. Head-height above the earth's crust, the eye scans a piece of continent, beholds a segment of the sphere's surface.

The spectator finds himself in the immediate presence of nature's vastness and vitality. All within the scene is excitement, exhilaration, flux. A million things happen before the eyes, too many things for the citizen of this sprawling country to take in at once. Still he notes the major events, those that tell of the ultimate meaning of the spectacle. A storm has just visited the scene. The waters are subsiding from the land. A rainbow, the sign of God's covenant with man, links heaven and earth. The spectator discovers himself as a New Noah, poised on the threshold of a New World. What a contrast to Chambers' decorative and to Cole's poetic waterfall! In Church's votive picture, *Niagara,* Nature at last revealed her spirit to the prophet-seer, painter-citizen. Niagara was an original symbol of America's destiny, a perfect union of the ideal and the actual.

Fundamental to the thinking of the aesthetically literate Romantic artist was the concept of form as implicit movement. Even the stasis of death implied movement—the absence of movement, in effect, zero movement. Every mode of movement, or of "action," to use the term commonly employed by the artists themselves, had its distinctive "expression." So, a tensed hand might express anxiety; a leaping pitchfork, exuberance; a drooping willow bough, sorrow. The action of the water in Church's *Niagara* will at one point appear as quiescent as the hair of Sully's sleeping child, at another as agitated as the hair of Mount's *Mr. Kean as Coriolanus* {pls. 19 and 18}. The clouds in *Niagara* are no less distinctive in their action. Low to the horizon above the Canadian shore they speed like arrows into the distance. Higher up they burst into the sky, like a volley of accelerating rockets. These celestial gestures bring to mind the bold sweep of

Apollo's arm, which Church would have known through a photograph {pl. 10}. The analogies between water and clouds and specific human features multiply until the human counterpart for every one of nature's actions is recognized.

Niagara is as much composed of a cast of characters as is, say, *The County Election* or *California News* {pls. 26 and 22}. In the paintings by Bingham and Mount each individual figure sustains its part in the larger over-all movement. In the one composition the movement begins slowly at the far left, its course passing through the relaxed body of the cider drinker; accelerating, it next plunges like a wave of humanity up the courthouse steps to crest and break with the figures of the oath-taker and clerk; the movement then anticlimactically tumbles from the porch to land with a thud on the back of the collapsed drunkard. In the other composition the movement dips and winds through the scene, eventually to escape with a bound through the post office door, coaxed on cleverly by the gun overhead, the prow of the advertised California-bound clipper, and the pointed nose of the exiting youth who has apparently decided to sail to San Francisco. In both *The County Election* and *California News* the movement of the composition itself comments on the spirit of the subject. So, on a cosmic rather than a human scale, does the entire composition of Church's *Niagara* {pl. 45} become, in effect, an Atlantean spasm of contracting-expanding movement: the water surges forward and downward as the horseshoe widens and the rapids stretch out and back; the clouds rush into the depths of space and sky. There is a compacting of sharp, aggressive forms on the right, and an opening of soft, gentle forms on the left. Heavens echo earth and earth echoes heavens in reciprocal configurations as opposite sides face one another, almost like man and woman. Up and down, in and out, to and fro are united in the arc that consecrates the scene. In the *Transfiguration* {pl. 16} Raphael skillfully managed to integrate two vertically aligned yet visually separate figural groups. In *Niagara* Church emulated the same dynamics of division and union as he joined earth to heaven to produce a landscape, rather than a figural votive picture. In the period of Transcendentalism, Nature succeeded Man as the principal actor in time and space. Church portrayed the excited spirit's

last word on Niagara. After him there was nothing for our artists to do in the presence of the great natural wonder but to forget God and Genesis.

In 1878 William Morris Hunt, concerned not with the Bible and a virgin continent, but with painterly technique and abstract design, confronted Niagara. Before his version of the Falls {pl. 45} we detect no subliminal Raphael. Our mind's eye, instead, turns to Hokusai and Hiroshige. Certainly the abstract composition and cut-off view point to Hunt's admiration for the Japanese print. And while Church handled paint as though it were nature's movement translated into oil, Hunt begins to negotiate between nature's movement and the movement of artistry. In other words, Hunt began to stress the process of execution: the reduction of the act of painting to the fewest strokes of the brush.

Although Hunt was trained by Couture and admired Millet, his *Niagara Falls* compares more closely with other Frenchmen. The handling of the paint brings to mind Courbet, a plausible influence, while the sense of light being reflected from the scene onto the eye comes close to paralleling the effects of Monet, a painter to whom Hunt would hardly wish to be compared. Hunt was rejecting the notion of the picture as a reconstitution of the scene in the mind's eye. In the process of abstracting design and simplifying technique he was turning from infinite nature to finite art. There was no spirit residing in the spectacle of Niagara waiting to be revealed by the artist. In subordinating the movements of nature to the techniques of execution, Hunt had abandoned one of the fundamentals of Romantic art: the premise that form is implicit movement. Without that premise there could be no inanimate drama to reveal the life of the spirit in the form. What spirit there was resided in the artistic act itself. With Hunt, secular, post-Romantic America found a new way to look at Niagara.

ARCHITECTURE AND HISTORIC ECLECTICISM

If landscape could be envisaged as inanimate drama, so too might architecture be envisaged as inanimate drama. One of the most spectacular and cogent illustrations of theatrically conceived architecture is Richard Upjohn's Trinity Church {pl. 42}. The design of the church lends itself easily to comparison with Allston's pencil sketch for the Angel releasing Peter from prison {pl. 43}. In the drawing the idea of release is expressed in the opposition of compression and expansion in the two principal figures. An analogous relationship exists between the two components of Trinity Church. In the nave, horizontal thrust prevails over the vertical. In the tower and spire, on the other hand, the vertical thrust exists virtually unopposed. The resting extension of the earthbound nave has thus been succeeded by the resolute, powerful surge of the heaven-aspiring tower. The building is in effect an explicit dramatization of its spiritual function. One might say that the thrust of the spire is paralleled at right angles by the clouds in Church's *Niagara*. In contrast to the spire the clouds lead not heavenwards, but towards unseen skies beyond the horizon. Hence, both stone and vapor gesture the spirit's aspirations.

These last two works of art are high-keyed drama. Distinctions in dramatic intensity were relished by the Romantic artist. Mount was obviously savoring such distinctions in a pair of sketches he made preliminary to painting *The Dance of the Haymakers* and *The Power of Music* {pl. 43} as he opposed solemn, quiet to explosive, noisy movement. A. J. Davis thought of buildings in essentially the same terms. He described architecture as "composing." With a vocabulary including walls and windows, buttresses and bosses, columns and cornices, he developed endless gradations in expressive movement. The individual features were then orchestrated to create the desired effect. To have striven for the high drama of a Trinity Church in the design of a private dwelling would, in his system, have been altogether inappropriate. Instead, he seems, perhaps quite consciously, to have conceived of the various units of a house as a familial cast of characters. For A. J. Davis to have thought in such terms would have been quite natural. His friend and associate Andrew Jackson Downing considered domestic architecture in similar terms: "It ought to be significant of the whole private life of man—his intelligence, his feelings, his enjoy-

ments." Beginning with the energetic, assertive form of the tower, which dominates the whole, and descending to the less energetic, less assertive subordinate units, Davis' "Lyndhurst" ⊰pl. 48⊱ strikes the viewer's mind as a charade of Dad, Mom, and the Kids. The movement of the ensemble has much the same animation as Mount's lighthearted rustics in *The Dance of the Haymakers* ⊰pl. 2⊱. We are reminded, too, of Downing's words: "It is true, the private life of many men is simple almost to monotony, but that of others abounds with infinite diversity." "Lyndhurst," we can be sure provided its occupants with a sense of variety and freedom.

In a confining environment such as a city block, architecture of more sober demeanor would be in order. Alongside "Lyndhurst," Davis' "House of Mansions ⊰pl. 48⊱ seems positively restrained in its movement. This urban entity stood for many years on the east side of Fifth Avenue between 41st and 42nd Streets. Davis was a master practitioner of "historistic eclecticism." Like many of his fellow-architects, he knew how to adapt Classical and Italianate to the secular needs of Wall Street ⊰pl. 21⊱. However, he was especially attracted to the Gothic style, doubtless because of its unlimited flexibility of form. Gothic was the most elastic of styles. It could, as we have just seen in the case of "Lyndhurst" and the "House of Mansions," be adapted to the needs of both the rural villa and the city row house. It could, as we observe in his sadly unrealized designs for The University of Michigan, be light, open, and intricate ⊰pl. 52⊱, or stiff, brittle, and monotonous ⊰pl. 52⊱; or, it could, as in his design for a chapel ⊰pl. 38⊱, be heavy, solid, and powerful. In his *The Departure,* Thomas Cole explored an extensive range of delicacy and strength of form offered by the medieval tradition ⊰pl. 51⊱. The active, energetic forms proved especially congenial to the spirit of the subject, the departure at dawn of an adventurous knight and his retainers. The scene is imbued with a sense of excitement and anticipation. The painting implicitly betrays the tacit assumption of the pantheist that the Gothic style is the style most sympathetic to nature as it echoes her ever varying forms. The fountain to the lower right answers to the lightness and openness of the nearby trees, the fortress on the prominence to the surging power of the looming mountain. In its own way, too, "Lyndhurst"

conformed to the freedom and irregularity—in a word, the picturesqueness—of the surrounding landscape.

Nothing could exceed the Gothic in attenuation, but beyond a point neither the Gothic, nor even the Romanesque, offered the degree of stolid massiveness that Davis on occasion desired of form. The Egyptian style was superlatively stolid and massive, and Davis made good use of it at times ⊰pls. 38 and 47⊱. Denser and quieter than anything medieval and more ponderous and more austere than anything classical, Egyptian forms proved especially suitable for the needs of cemetery architecture. How suggestive of the immobility and permanence of death, indeed, is Davis' design for a cemetery entrance ⊰pl. 47⊱. Tuscan or Doric columns, the sturdiest orders of classical architecture, would have been too elate with life.

The inertia of these pseudo-Egyptian columns (Davis Americanized them with corn-cob capitals) bespeaks the grave. And the extended, reiterated horizontals of the mass proclaim eternal rest. What a contrast between these relentlessly unvaried straight cornice lines with their monotonously repeated decorative motifs and those expanding straight-lined rapids in a sea of infinitely varied water action presented to the eye by Church's *Niagara* ⊰pl. 45⊱! In the former we see the sublime in death; in the latter the sublime in life. In this regard it should be kept in mind that the historical associations of Egypt's mortuary temples, the source of this most ancient and most funerary of styles, were an important literary adjunct to the funereal expression of the style's lines and masses. So too might the peculiarly Christian or academic or chivalric associations of the medieval period incline the architect to favor the Gothic style. Cole's evocation of the Age of Knights and Ladies, *The Departure* ⊰pl. 51⊱, so reminiscent of Sir Walter Scott, is, of course, another expression of this literary impetus. Alongside this painting, the same taste for romance in Irving's "Sunnyside" and Davis' "Lyndhurst" comes into focus. Davis, in fact, quite purposefully nourished his imagination on "Gothick" novels. His designs for a cemetery entrance and a chapel facade offer a most telling contrast between the Egyptian and the Gothic styles, according to their intrinsic appropriateness of expression and association. The one proclaims the stasis of death

and the idea of eternity, the other, the aspiration of the soul and the memory of the most Christian of eras ⊰pl. 38⊱. Almost a perfect reconciliation of these two so disparate forms is the obelisk already familiar to the reader from the discussion of the Bunker Hill and Washington monuments ⊰pls. 41 and 39⊱. It is a form which fuses the stability and timelessness of the one with the uprightness and elevation of spirit of the other.

In the American context, historical associations did not always reach back in time beyond Columbus. Indeed, the association might even date from as late as the Colonial period. Steeping himself in the history of the Hudson Valley, the author Washington Irving started in 1832 to convert his house in Tarrytown into a stepped gable cottage, which in his imagination he proceeded to people with Dutch settlers ⊰pl. 50⊱. "Sunnyside" is more cozy and less dramatic in its effect than is its nearby neighbor, "Lyndhurst," even in the latter's earliest form ⊰pl. 53⊱. Though eclecticism was indispensable to historical association, it was not essential to other forms of association or expression. Thus, for example, Bonfield's *Drifting Snow* presents, without any reference to another era, an image which juxtaposes the promise of domestic comfort in the farmhouse and winter's harsh cold ⊰pl. 50⊱. Common everyday experience, such as family life, could itself offer an artist an abundance of associations.

EXPRESSION UNLIMITED

Repeatedly in the Romantic period the forms of one historical style might be disengaged from their original contexts to be combined with the forms of other historical styles and placed in new contexts. Iron stove design lends itself as a case study. One model patented in 1847 exhibits a delicate amalgam of Gothic and Rococo; another patented in 1854 exhibits a somewhat bolder amalgam of the two styles, while its "roof" hints at still another style, Chinese ⊰pl. 54⊱. In suggesting itself as a little house of heat, this stove inspires not reveries about the remote in time and place, but sentiments about the home. A superb example of "synthetic eclecticism," this confection of 1854 shows how the forms of past and exotic styles could be separated from history and looked upon as intrinsically expressive. Like the spire of Trinity Church or the platter of ham in Mount's *The Dance of the Haymakers,* stoves might suggest human feelings and actions. For instance, the stove of 1847 almost parodies the mincing gait of *Godey's* over-feminine ladies. Alongside this genteel parlor piece, the stove of 1854 appears rowdy and aggressive, a cast-iron roué. The sexual analogies are not altogether amiss. Our Romantic ancestors habitually emphasized the strength of men and the delicacy of women. Yet they allowed only the chastest of nudes to be represented, and these generally in cold white marble. Even at that, the semi-nudity of his Washington, regardless of the identity with Zeus, was something that shocked Greenough's public and contributed to the statue's sad fate. The compulsive avoidance of anything explicitly sensual may itself have spawned such covertly sensual forms as these two stoves.

The celibate Shakers, whose whole lives revolved about the concerns of the spirit, eschewed such proxies for sexual expression. Much has been made of the rationalized "functionalism" of Shaker design, but it should not be forgotten that this functionalism was as religious as it was practical. The Shaker stove illustrated here ⊰pl. 54⊱ has nothing of that quality of sensuous bodily action suggested in the other stoves. This stove almost denies the weight and plasticity of cast iron. Its serene form is static and astonishingly suggestive of the immobility of an Egyptian pylon ⊰pl. 38⊱. The very accident of this resemblance itself surprises us as it discloses the peculiar position of the Shakers in the Romantic system. Despite their utilitarian objections to any of the whims of fashionable eclecticism, the Shakers still conceived of form as intrinsically expressive. They simply extended the system to one of its potential extremes. How appropriate that a people who denied the importance of secular history would reject historical associations! They were concerned not with the letter, but only with the spirit of style.

In the mid-century the gradations and the contexts of expressive form became practically infinite. Ultimately, of course, expressive form was, as has already been observed, simply the embodiment of

human emotions. Indeed, the original source of expression was man's own image. The process of the translation from human to non-human is vividly illustrated in the juxtaposition of two drawings by Thomas Cole, one of a sculpted nude, the other of a tree {pl. 37}. The implicit anthropomorphism of the tree immediately becomes explicit. The contours and the movements of the two objects are essentially of the same order, though the one suggests struggling and pain, the other, relative repose. It comes as no surprise that the painter in his journal compared trees to men. In his wanderings through the landscape Cole again and again sought out those trees that answered to the various stances of his own spirit: torn and devastated, ecstatic, serene {pls. 62 and 73}. Cole's sense of his own body might literally, in the drawing of a tree, define his perceptions of nature {pl. 61}. The tree, by the very discreteness of its form, lent itself readily as a proxy for man in the landscape. But the anthropocentric tendency was so persistent that light and atmosphere could be humanly expressive in that they might strike an emotional chord in the mind. Thus Cole noted the "melancholy expression" of a twilight sky {pl. 72}.

Cole viewed nature as a repertory of divinely-ordained effects. Church, in contrast, viewed nature as a revelation of divinely-ordained laws. He perceived expression in nature, but it was the expression of nature and not of himself. He saw qualities of power and repose in the contours of icebergs as Allston had seen the same qualities in the contours of the human hand {pls. 24 and 25}. It was through scientific observation and synthesizing of the contours of power and the gestures of repose, aspiration, and triumph that Church revealed the spiritual meaning of global forces. In Church's mind, man and nature might become reconciled. His impulse, thus, was to seek his redemption in nature, to be born again in the New World as a New Adam. An unofficial Transcendentalist, all nature for Church was instinct with spirituality. "Strange, supernatural," he noted of an iceberg as he sketched it from a distance one July day in 1859 {pl. 72}. Icebergs were infinitely varied in form, infinitely rich in expression, infinitely suggestive of resemblance. Hence *The Icebergs* could portray the fulfillment of a divinely-ordained cosmic urge {pl. 24}. Artist

and spectator themselves became one with each other and with the scene. There was perfect rapport between man and man, and man and nature. All fused in the union of spirit and matter.

As Church and his contemporaries in the age of Pantheists and Transcendentalists strove to merge with nature, nature in its infinite variety of form and expression seemed to emerge in the objects they created. Form as action, form as psychological expression, form as plastic spirit was the rule in everything from buildings to stoves, and from styles of furniture to styles of typography. Note the unlimited variety of expression indicated in the selection of the four chairs included in the exhibition. There is the self-restrained immobility of the very plain chair in plate 64, so true to Shaker form, and the almost waltzing undulation of the Belter style chair in plate 56. Two other chairs embody the nineteenth-century spirit in the guise of the Rococo. The more delicate of the two {pl. 64} betrays the restlessness of the age, the other {pl. 63} its energy. This latter, a synthesis of the Rococo, the Gothic, and the Italianate, is a choice example of eclectic hybrid vigor. The versatility of expression of these chairs is, in turn, matched in the lettering styles of the period. An advertisement for a stove company seems to duplicate in its variety of print, the variety it offers in its wares {pl. 55}. One type strikes the eye as tall and stately, another as blunt and compressed, another as restless and lively. Suitability was automatically considered in the choice of lettering. P. T. Barnum enticed the public into his museum beneath a sign that in its very shapes promised excitement {pl. 77}. Stoic, sober lines would hardly have fitted the spirit of curiosity which he wished to exploit. But nothing other than stoic, sober lines would have fitted the spirit of George Washington, a propriety observed both by Rembrandt Peale and Horatio Greenough {pls. 31 and 34}.

The same language of form manifested itself universally. The expressive cognate of the excited lettering over the entrance to Barnum's Museum is the chairback in plate 63. Similarly excited are the lines of the rib tracery in Davis' design for the dining room at "Lyndhurst" {pl. 65}, a design to be executed in lath and plaster. (That the rib vaulting was to be simulated purely for effect

rather than reproduced structurally underscores the architect's indifference to matter *per se*. With Davis "expression" referred to articulation not of the physical means, but of the spiritual ends of his art.) Outdoing, in turn, the excitement of the chairback and ceiling tracery is the frenzied silhouette of a tree drawn by Thomas Cole ⊰pl. 62⊱, an effect that rather closely resembles a grotesque head sketched by the same artist ⊰pl. 60⊱. Lower on the scale of emotional intensity is the tree which Cole created for his *American Lake Scene,* a tree that postures a mood of hushed expectancy, the moment of awakening just before sunrise ⊰pl. 69⊱. The shape of expectancy in the tree itself evokes the sense of alert watchfulness shaped by the horns of startled deer on the prairie stopped in their tracks by the sound of danger ⊰pl. 68⊱.

The forms of nature and of history were continually being appropriated by the artist and the designer. Thus Church in the North Atlantic discovered a mine of prodigies in the forms of icebergs. A. J. Davis and his immediate successors in architecture were to seek out ever more obscure styles to assimilate. Barnum, too, had a voracious appetite for the discovery of more curiosities. But it was not just for more variety that our ancestors pushed back the frontiers of the known to confront the unfamiliar. They were impelled by an insatiable desire to take possession of the most expressive, to seize the hyperbolic—better still to invent it. The designer of the iron stove of 1854 might well have regarded the iron stove manufactured in 1847 as not sufficiently exciting, while the designer of that earlier stove might have thought his own creation the last word in molded excitement ⊰pl. 54⊱. So, too, a still-life of the 1820's, such as that by James Peale, would doubtless have impressed Severin Roesen a generation later as rather too restrained and tame ⊰pl. 57⊱. The Peale has something of the reticence of Phyfe furniture, just as the Roesen has something of the exuberance of Belter furniture. There was a steady amplification and escalation of expressive effects that continued into the 1860's.

THE INDIVIDUAL AND HIS SALVATION

Church experienced life as a New Adam; Cole experienced life as a fallen Adam. He called this world "a vale of tears." A study for *Manhood* ⊰pl. 58⊱, the third in his series of four entitled *The Voyage of Life,* typifies Cole as *The Icebergs* typifies Church. In a landscape fraught with peril to the human soul, the hero proceeds along the stream of life's vicissitudes knowing that his only hope for salvation is to persevere in faith to the very end. The scene is the dark night of the spirit. Trees writhe in torment. Cliffs loom forward threateningly. Overhead, demons hover in the clouds. About to greet the hero at his next turn is the horrible face of a goblin emerging from a rocky precipice. In the heavens, unseen by this humbled and now proven mortal, a guardian angel presides benevolently over the destiny of his soul.

Picturing a theme dear to the heart of many a reader of *Pilgrim's Progress* or of any one of hundreds of Bible tracts circulating at the time, the engraved publication of Cole's series, *The Voyage of Life,* proved to be immensely popular with the American public. *Manhood* was undoubtedly the psychic self-portrait of those countless Puritan spirits who shared Cole's belief that salvation was an individual matter. But not everyone sought immortality in lonely isolation. For the collectivist Shaker, salvation was a communal enterprise. The individual, as we may infer from the print of a Shaker dance or worship, surrendered his individuality as he or she assumed the identical dress of brothers or sisters of the faith and, at the direction of the Holy Spirit, danced in unison with them ⊰pl. 66⊱. There was a period in the 1830's and 1840's when, perhaps reflecting contemporary enthusiasms for séances and table-rappings, certain favored members became private amanuenses to Holy Mother Wisdom, the deceased founder of the Shaker movement. A "spirit drawing" executed by Hannah Ann Treadway is reproduced in plate 59. It abounds in promises of "life everlasting," anticipations of the Apocalypse, admonitions to the faithful. Alongside its counterpart in an anonymous mourning picture ⊰pl. 46⊱, the weeping willow (it stands just to the left of a building identified as

"the Prison where Mother Ann was confined after she came to America") seems positively cheerful. Nearby, an "Instrument of Heavenly Music" suggests to us a Rube Goldberg contraption drawn without tongue-in-cheek. Pressed into a two-dimensional realm and not subject to the laws of gravity, it becomes the ethereal ideal striven for in the Shaker stove and chair. Near the top, wings of the "Heavenly Father" and of "Holy Wisdom" hover. A large constellation of concentric circles bears the legend, "The Heavenly Father's Words"; a smaller one, "The Prophet Daniel's Prayer when in the Lion's Den." At one point the eye discovers "A basket of heavenly fruit," at another, a "Spiritual Lamp." And what is the clock with the impossible hour? The end of time? Eternity? The flat and weightless world of this "daughter of Zion," Hanna Ann Treadway, is the antithesis of that burdensome one of the afflicted Thomas Cole. Here there is no time, no struggle. The trees do not writhe and twist in the agony of life's experience. The blank surfaces and thin trim of the church where the brothers and sisters surrendered their bodies to the dictates of the Holy Spirit ⊰pl. 66⊱ belong to the same unworldly world of this "spirit drawing." How different the Shakers' setting for worship is from that of their cosmopolitan cousins ⊰pl. 42⊱! The striving and release of Trinity Church almost paraphrases in architecture the story of Cole's *The Voyage of Life*.

THE GROTESQUE, DIABOLICAL, AND COMICAL

It is curious how the innocent Shakers avoided any hint of the diabolical. Strange objects may appear in a spirit drawing, but nothing that smacks of the grotesque. To the more worldly artist, however, the grotesque as the guise of evil, both serious and comic, was an indispensible contrivance. Cole resorted to it from time to time. Perhaps he found the sketch illustrated in plate 61 of service as he painted that goblin-faced rock in *Manhood* ⊰pl. 58⊱. A craggy cliff he once drew suggests a grim, taciturn Indian ⊰pl. 61⊱. An amusing instance of the grotesque in comic form would be the cartoon from *Davy Crockett's 1847 Almanac* of "Crockett Delivering His Celebrated War Speech" ⊰pl. 60⊱. The cartoon accompanies a text of verbal pyrotechnics invented for the spurious almanac.

The classic example of the comic grotesque in this exhibition, however, is Quidor's *Wolfert's Will* ⊰pl. 67⊱, a delightful illustration of a passage from Irving's *Tales of a Traveller*. The scene depicts Wolfert Webber who has, in the course of drawing up a will to dispose of a farm, just learned from his lawyer that the property is soon to be "laid out in streets, and cut up into snug building lots," and "whoever owns it will not need to pull off his hat to the patroon!" The status-starved cabbage grower rises abruptly from his supposed deathbed to announce that he has now something to live for and will thus postpone dying indefinitely. In the heads of the two principals, Quidor has struck a delicate balance between the grotesque and caricature. The overstatement of character and expression just suffices to compensate for the absence of speech and to distinguish the situation as comical rather than tragic. The entire scene, in turn, registers at once both the new excitement in life for Wolfert and the gleeful spirit of his solicitor. The bedpost bounds upwards with the same zest as the revived burgher, while his informant's chairback seemingly chuckles and guffaws. Quidor's ingenuity here extends the repertory of chairback gestures beyond the gentilities of the parlor, into the excesses of the chamber of laughable horrors. Apropos of such a setting, it will be recalled that Allston hinted at the pagan spirit of Belshazzar's court by the graceless device of a fat three-legged minorah stand ⊰pl. 3⊱. Comically rather than heathenly graceless is the andiron in *Wolfert's Will*. If Mount could compare Mills' design for the Washington monument to a bug ⊰pl. 39⊱, we can be sure that Quidor did his best to make this andiron act the part of some unsightly creature, perhaps a gloating flea ready to bite. What does not show in a black and white photograph is the bizarre palette of poison green and sulphurous yellow of this eerily lit, dingy retreat of the bedridden money-grubber. *Wolfert's Will* is a masterful fantasy of unreal yet convincing expression. It brings the impossible to artistic life.

[20]

One of the most popular subjects of Romantic art, animals, has barely been mentioned so far. Actually, animals have appeared in roles of varying importance in a number of paintings already considered. For example, a close viewing of *Wolfert's Will* rewards the eye with the discovery of a minor incident that fills a few square inches of canvas between the desk and the hearth. Here a cat, "the only unconcerned member of the family," unwittingly contributes to the general sense of excitement as she pounces on a ball of yarn ⁅pl. 67⁆. A rather less active cat in *The Dance of the Haymakers* ⁅pl. 2⁆, cozily ensconced under the barn floor, stares unconcernedly at a dog who seems, like his traditional enemy, to have succumbed to the spell of the moment. A slightly more prominent role was assigned the dog in Ranney's *Duck Hunters*. In this scene, the animal's keen alertness serves as an index to the tensed, hushed excitement of his masters ⁅pl. 70⁆. In the more explosive drama of Wimar's *The Attack on an Emigrant Train* ⁅pl. 20⁆, reeling, terrified horses expose the true horror of the incident. The very antithesis of such wild commotion appears in *Washington before Yorktown* ⁅pl. 31⁆. Here, the painter Peale, echoes the impassive calm of the general in the expression of the horse.

In all five of the paintings just now discussed animals remain essentially adjuncts to the human action. The only true animal painting thus far considered has been Audubon's *The Eagle of Washington* ⁅pl. 33⁆. It is in effect an ornithological state portrait in the tradition of Titian and Reynolds. No bird lent itself more readily to heroic representation than the eagle. Its commanding dignity had already in Roman times made the bird a symbol of authority and empire. As emblem of the new nation it might witness the ascent of Washington or adorn his throne ⁅pls. 30 and 89⁆. It might preside over the senate chamber, embellish the bow and stern of *The Great Republic,* or cap a stove ⁅pls. 27, 25, and 55⁆. With wings spread wide, it might climax a masterpiece of penmanship, or hover over a store front ⁅pls. 28 and 71⁆.

The eagle was not alone, however, amongst the creatures who were honored with an almost human dignity. Thus *Ossisuak* is a splendid characterization on Church's part of animal personality ⁅pl. 78⁆.

At a distance this Arctic Husky looks forbidding. Up close, he becomes a dog who is still part puppy as he looks entreatingly up at the viewer. In *The Peaceable Kingdom* by Edward Hicks, the lion possesses a regal, if somewhat quaint, majesty ⁅pl. 76⁆. One is reminded of the common practice of the day to look for the moral characteristics of the animal in the person who resembled that animal. The most famous comparison was that of the lion to Daniel Webster, or, rather, Daniel Webster to the lion. Hicks' lion and Chandler's *Webster* ⁅pl. 79⁆ provide the right visual accompaniment to this moral conclusion drawn by the Fowlers:

Some men closely resemble one or another of the animal species, in both looks and character; that is, have the eagle, or bull-dog, or lion, or baboon expression of face, and when they do, have the corresponding characteristics. Thus the lion's head and face are broad and stout built, with a heavy beard and mane, and mouth rendered square by small front and large eye teeth, and its corners slightly turning downward; and that human 'Lion of the North'—who takes hold only of some great undertaking, which he pursues with indomitable energy, rarely pounces on his prey, but when he does, so roars that a nation quakes; demolishes his victim; and is an intellectual king among men—bears no slight physiognomical resemblance in his stout form, square face and mouth, large nose, and open countenance, to the king of beasts. *(The Illustrated Self-Instructor in Phrenology and Physiology)*

Hicks' concern with animals was similar to that of the Fowlers, but it was anchored in the eternities of the Bible instead of the short-lived faddisms of a pseudo-science. The Quaker preacher-painter based his subject on a passage from Isaiah which he paraphrased in a poem:

The wolf shall with the lambkin dwell in peace,
His grim carnivorous thirst for blood shall cease,
The beauteous leopard with his restless eye,
Shall by the kid in perfect stillness lie:
The calf, the fatling, and young lion wild,
Shall all be led by one sweet little child.

In a harangue urging his co-religionists to return to the ways of their ancestors (they are alluded to in the painting through the reference to West's *Penn's Treaty with the Indians*), Hicks spelled out the moral strengths and weaknesses, each respectively, of the four temperaments. In *The Peaceable Kingdom* animals personify aspects of the various

temperaments. So, for example, the wolf is the emblem of the melancholic, the leopard of the sanguine, the cow of the phlegmatic, and the lion of the choleric. As Webster resembled the lion, we may suppose that Hicks would detect a tendency towards inordinate anger as a moral liability of the statesman.

If animals were to Edward Hicks essentially emblems and counsels to the spirit, they were to Phineas T. Barnum essentially curiosities and comforts to the wallet. Pictured across the facade of Barnum's museum are dozens of animals, some sublime like the eagle and the lion, others beautiful like the swan and the peacock, but most more picturesque than sublime or beautiful: the elephant, the walrus, the crocodile, the boa constrictor, the cormorant ⊰pl. 77⊱.

In his tastes in natural history the showman was as eclectic as A. J. Davis was in architectural history. Church found the unique in an iceberg; Barnum, in an ostrich. Quidor relished the grotesque in an andiron; Barnum, in a creature that looked half camel, half leopard, the "camelopard," what we call the giraffe. Barnum appealed to his age's fascination with extremes.

More classic than Gothic in their taste, John James Audubon and his sons were more concerned with documentation than with entertainment. John James Audubon throughout his career reflected the academic biases he had acquired in the studio of Jacques Louis David. No wonder he discovered human dignity and beauty in the animal kingdom, as in his *The Eagle of Washington* ⊰pl. 33⊱. Audubon's influence is pervasive in the prairie scene attributed to his sons ⊰pl. 68⊱. The startled deer halt and turn with grace and poise. Behind the artists' eyes there seem to be memories of a frieze of antique maidens performing a dance or rite. The senior Audubon's aesthetic bias, however, did not blind his eyes to scientific truth. That he could capture the lumpish, ungainly features and ugly snarl of the wolverine is proof enough that Audubon was a connoisseur of animal character as well as animal beauty ⊰pl. 82⊱.

Animals in the Romantic period shared with landscape and architecture the characteristic that beneath the surface there is often some essence of the human body and the human situation. Much of the time the artist may have been only vaguely, if at all, conscious of the tendency to anthropomorphize. One artist, however, whose tendency to anthropomorphize was anything but unconscious was William H. Beard. His animal pictures often make no pretense at documenting animal behavior. *Susanna and the Elders,* portraying two horned owls surprising a swan at her bath, is a charming example of his work ⊰pl. 80⊱. As Church's heroic *Niagara* invokes Genesis, Beard's creature parody invokes the Apocrypha. Thus two seemingly unrelated images, one sublime, the other ridiculous reveal extremes of the Biblical set of mind in Protestant Romantic America.

Beard, without any apologies, might choose to ignore the actual behavior of animals. His owls and swan are feathered puppets who mimic the character and expression of men and women. Mount, in contrast, extended his observations of character and expression beyond the human into the animal realm. As he lived in rural Long Island, the barnyard was always available to his view. *Ringing the Pig* is a charming and masterful presentation on Mount's part of the subtleties of porcine reactions to man's will ⊰pl. 81⊱. Protest and pain are written across the hapless hero's face, if face is the word for such a physiognomy. Still, despite Mount's keen study of the individual animal, the scene itself portrays a man's-eye view of the situation. Thus, one of the early viewers of the painting, expressing his regard for the *esprit de corps* of the hog, referred to the victim's fellow swine as "friends." *Ringing the Pig* is a drama of the interaction of man and beast, an adaptation of the Grand Style to the everyday world of the yeoman farmer.

In the Romantic period animals are typically conceived as symbols or actors. However, they might sometimes figure as essentially decorative motifs. *The Chase,* a superb display of ornamental penmanship by a "J. M. Gibbs," serves as an example ⊰pl. 71⊱. If we compare the dogs, or the eagle, or the deer in this calligraphic drawing with those considered in the discussion above, we discover that in each case a portion of the animal's character and expression has been sacrificed to the decorative logic of penmanship. This is particularly noticeable in the deer if we examine them alongside their more naturalistically portrayed cousins in the painting attributed to the Audubons ⊰pl. 68⊱. In the drawing the springing action of the deer has more to do with

the rhythm of design than with the organic function of the body. The primary expression of the artist's spirit is the rigorous, and morally beneficial discipline of penmanship itself. The drawing is in a sense a certificate of the executor's patience and labor. Little if any subjective indulgence survives this process. The drawing is an exercise in the Protestant ethic of self-control and industry. The other extreme of that ethic is the soul-searching examination of nature that produced the heartfelt drawings of the Romantic, Thomas Cole. Compare the intensely personal intimacy of his study of blasted trees ⊰pl. 73⊱ with the impersonal detachment of Gibbs' showpiece. Our thoughts are brought back to the contrast between Cole's and Chambers' versions of Niagara Falls. The parade of scalloped lines across the bottom of *The Chase* is near kin to the decorative bands of waves that appear below the falls in Chambers' painting ⊰pl. 44⊱. Once again, we discover characteristics that do not conform to one of the basic principles of Romantic American art as defined in this essay. Naive and folk artists, unlike their more sophisticated contemporaries, conceived of form not as implicitly expressive movement, but as abstract rhythmic pattern. Theirs was an undated form of art, affected only by aspects of Romanticism, most notably subject matter.

THE END OF ANTHROPOMORPHIZING

In full-fledged Romantic art, animals were emblems or characters, sublime, beautiful or picturesque, representing ideas or expressing emotions, inspiring or pleasing or amusing. As Romanticism came to an end, animals ceased to be portrayed as the servants of man's thoughts and feelings. Science, perhaps, did as much as anything to destroy the anthropocentric view of life. As long as man could look upon himself as a unique being, created in God's image and endowed with a soul, he could look upon himself as separate from and superior to his fellow creatures. But when it became evident, as Darwin demonstrated in his *Expressions of Men and Animals,* that man's sneer related him hereditarily to the snarl of the dog, or, for that matter, of the pig or of the wolverine, the notion of his uniqueness was doomed ⊰pls. 81 and 82⊱. The implications of the "canine snarl" undermined the concept of expression as the language of the human soul. After this, animals acted the part of animals in the struggle for survival. If anything of the human soul is expressed in Alexander Pope's *The Trumpeter Swan,* it is an indictment of man's rapacity ⊰pl. 83⊱. As he has wantonly destroyed a beautiful creature, man has converted both the creature and himself into soulless things, brute actors in a world governed only by contending forces.

Pope's *The Trumpeter Swan* ⊰pl. 83⊱ reflects the secular vision of post-Romantic America in its absence of anthropomorphizing thought and action.

A similar impulse to neutralize form, in this case an object rather than an animal, is illustrated in Jefferson Chalfant's *Violin and Bow* ⊰pl. 8⊱. Though the violin is elegant as a form, it is not in any sense a dramatic prop. While Allston and Mount would conceive of a lute, or a banjo, or a fiddle as forms expressive of mood ⊰pls. 7, 6, and 2⊱, Chalfant conceives of the instrument as a physical object. His concern is with the structure, the weight, the plasticity, the history—in a word, the self-sufficiency—of the violin. Matter now exists in its own right, subject not to the ephemeral whims of the human spirit, but to the inexorable laws of gravity. In the later nineteenth century, a period of disillusioned ideals and chaotic growth, the intimate and personal vignette of nostalgia and familiarity of William Harnett and his followers like Pope and Chalfant provided the very antithesis of the mid-century's grand collective panorama of time and space, of past, present and future. To see without any distorting preconceptions of association and feeling, without any hint of heroic symbol, of human character or drama is the instinct of the *trompe l'œil* artists. Reacting against the subjectivism of Romantic vision, their passion became detached examination. With them the act of interpretation was of secondary consequence. The fortuitous and the cryptic obscure whatever message there may be. In the era of the excited spirit the artist revealed the clarion imperative. Ulterior thought preceded specific perception. In Pope's

[23]

The Trumpeter Swan and Chalfant's *Violin and Bow* there is no cogent ulterior thought to precede specific perception: perception itself *is* the motive. There was nothing certain to be revealed beyond what one could see with the naked eye.

The *trompe l'œil* artist sought to outdo the camera in deception of the eye. This was just one manifestation of the post-Romantic drifting away from the concern of the spirit. Chalfant (who, incidentally, was once a cabinetmaker) sought to rebuild the object on the canvas as he eliminated the traces of the artistic process. William Morris Hunt, in contrast, strove to emphasize the artistic process at the cost of the object represented. However, like Chalfant, he rejected the anthropomorphizing of Allston and Mount. In contrast to *The Evening Hymn* {pl. 7} and *The Banjo Player* {pl. 6}, Hunt's *Young Woman with a Guitar* {pl. 9}, despite the subject, conveys no sense of mood. He disdains the careful attention to the contours of the instrument that had been indispensable to poetic expression. The surface of the guitar is broken rather than built by the brushstroke. Superficially the waving lines of pigment denoting hair and clothing bring to mind Inman's animated portrait of *William Macready* {pl. 13}. But with Hunt the waving lines no longer indicate excitement. Instead, they trace the sweep of the hand as it applies oil to the canvas. In the Romantic painting, movement expressed emotion. Now movement expresses process, the process of the act of painting.

Although no examples of American Impressionism are included in this exhibition, anticipations of it are represented by several works. One, *Niagara Falls* {pl. 45} by William Morris Hunt, has already been discussed [see p. 15]. Another is the view of *Mount Washington from Lake Sebago, Maine* by J. F. Cropsey, painted in 1871 {pl. 75}. Knowing that the painter early in his career modeled himself after Thomas Cole, it is especially instructive to compare the latter's work with this work of Cropsey's maturity. While Cole depicted Mount Washington as a hoar-headed granite god, a New England Olympus {pl. 74}, Cropsey depicted it as a golden-hued translucent screen, an object to trap the palpable radiance of air. Cole presented a large body of water as the first stirring of life at the birth of day {pl. 69}; Cropsey, as a mirror reflecting the depths of a shimmering sun-drenched atmosphere.

Cropsey now, almost a quarter century after Cole's death, was modeling himself after Sanford R. Gifford, painting the life of light. The change is evident even in the casual on-the-spot penciled impression. No reflection of human action survives in Cropsey's study of a tree reproduced in plate 62. The only action is that of light dissolving form. Cole would have rolled over in his grave: expression, association, symbol, were vanishing from the scene. If any emotion or idea remains, it is the artist's awe at the divinity of light.

Actually these tendencies in Cropsey's work were already becoming evident in American painting twenty years before. Looking forward to the absorption with light in the '70's, our luminists of the 1850's and '60's, Fitz Hugh Lane, Martin Johnson Heade, John F. Kensett and Sanford R. Gifford, were advancing gradually, perhaps unwittingly, along the path of secularization. Though there may be mystery or glory in their vision, there is little, if any, inclination on their part to anthropomorphize. The impulse to unite with nature, the impulse that induced Cole to impose upon nature and Church to lose himself in nature, brought the humanism of the Renaissance to a surprising conclusion in the American wilderness: a merging of the body with the elements. This is one of the consequences of that Puritan urge to cast off the flesh and become all mind and spirit. Another consequence of that same urge is exemplified by "luminism." Instead of merging with the drama of the forces and viscerally reliving nature's life, the luminist becomes a disinterested eye, suspended in time and space, attached to no body, a lens opening to pure intellect.[6] The luminist painter is a passive looker. His stance is still and static. His mind organized landscape not as expressive movement, but as mathematical order. The light in his

[6] In *American Painting of the Nineteenth Century* (New York, 1969), Barbara Novak aptly applies to the luminist's vision Emerson's definition of the ideal Transcendentalist painter as "a transparent eyeball." However, it has seemed to me that there is latitude enough in Emerson's words to regard the term as equally applicable to the illusions of reality created by Frederic Church (see p. 14). Before such of his pictures as *Niagara* or *Twilight in the Wilderness* spectators imagined themselves in the very presence of nature. The artist had seemingly removed himself totally from the scene—in effect become transparent. James Jackson Jarves *(The Art Idea)* regarded *Niagara* as indistinguishable from a photograph.

painting may have been perceived religiously, but the luminist painter's imagination remains inactive, neutral. There is no staged drama of the soul, no cogent revelation of prophecy fulfilled, to be cele-brated in Cropsey's Indian summer view of Mount Washington. The painting itself marks the Indian summer of Romanticism, a brilliant and final glow of the spirituality of light.

HOMER AND EAKINS AND THE SECULAR SPIRIT

Completely secular in spirit is the work of the earliest of American artists to be compared to the Impressionists, Winslow Homer. One of his favored subjects, the interior of a New England country school, typifies this painter as he was developing in the post-Civil War years ⊰pl. 93⊱. Gone completely now is the Romantic conception of light as a concomitant of mood, or of light as a manifestation of God. Sunshine pours through transparent panes and translucent shades to strike surfaces here and there and then, reflected, to bounce about the room. Devoid of drama or mystery, the light is purely physical, uninfluenced by human thought or feeling. The forms, too, are equally unconscious. Whereas at "Lyndhurst" the ceiling seems all action and expression ⊰pl. 65⊱, here it is simply a colored shape. In works by Allston or Ranney or Mount, a column, or a punt, or a pot would contract, or stretch or point; here, a table, a bench, a pitcher, make no gesture whatsoever. In Romantic painting the viewer involved himself with the situation pictured, whether high-keyed drama or low-keyed mood; here the viewer is uninvolved, and there is neither drama, nor mood—just a passing glimpse of an indeterminate moment in the slow and uneventful process of schooling. We cannot imagine Bingham choosing such a subject. And what would he have thought of Homer's anonymous, impersonal figures who are barely more conscious than their setting? The genre painters of the mid-century, most of all Bingham, relished the orchestration of a host of sharply-defined individual characters in a complicated setting ⊰pl. 26⊱. Homer, on the other hand, with seeming deliberation neutralized character and simplified setting. The painting ceased to be read in time like a picture story. It became, instead, an instantaneously perceived image. Stripped of literary content, it no longer needed the old vocabulary of stage props. Economic pictorial structure—direct, clear, and forceful—became the new imperative. Hence the theatrics of Raphael's *Transfiguration* gave way to the ab-stractions of Hokusai and Hiroshige, as Homer presented an unarresting glimpse (it is not a stage scene) of an "any-moment" in an "any-school." A very few light and dark, warm and cool colors, a limited number of shapes, and a bold and decidedly Japanese effect in black have been extracted from the situation portrayed. Indeed, these abstract features create the situation as much as do the preoccupied children and schoolmarm.

Homer's rejection of character in favor of anonymity, and of complexity in favor of simplicity are summed up in a few pencil strokes in his drawing of *Adelaide Cole* ⊰pl. 92⊱. To compare it with Bingham's drawing of *Two Citizens* ⊰pl. 1⊱ is to observe the essence of the revolution accomplished by Homer. In Bingham's drawing we learn about the character of the two men through accumulated observations. A face is most revealing but even when it does not show, the stance and gesture, the folds of the jacket, and the turn of the hat tell us enough. But in Homer's drawing no memory of classical expression in face, pose, and clothing survives. The girl's pose originates solely in a functional act. Her hat gives us no hint as to her character. Bingham's illusionistic considered nuances of modeling in light and shade have given way to a few boldly sketched pencil strokes that frankly transfer a visual impression onto a flat piece of paper. Homer's taste for anonymity and for simplification is a reflection of the new mentality being fashioned by the experience of urban life and the efficiency of corporate organization that were transforming the face and the ways of post-Romantic, post-agrarian America.

Another major force in the fashioning of the new mentality was science. Although Homer in painting "un-dramas" (to coin a word for the occasion) introduced the concept of action as process or operation, the concept was much more central to the art of one of his younger contemporaries.[7] Process and operation were fundamental both as subject and as method to the scientist, and

no artist was more the scientist than Thomas Eakins. In the older generation Frederic Church would have been the only artist to have exhibited an equal passion for science. The difference in the orientation of the two to their common passion reveals itself in their respective portrayals of dogs. Church painted his Husky *Ossisuak* as though he were confronting the dog as man, searching personality ⊰pl. 78⊱. Eakins, in contrast, photographed his setter *Nance* ⊰pl. 82⊱ in such a way as to seize a characteristic aspect of dog behavior. As post-Darwinian as Church was pre-Darwinian, Eakins had no impulse to anthropomorphize. To him, the resemblance of man and beast originated solely in their common heredity as animals. Hence his complete ease in studying on one page both the head musculature and leg-bone of the horse and the knee joint of the human ⊰pl. 86⊱. His casts of horse anatomy inform us of one of the many courses he pursued ⊰pls. 84 and 85⊱.

Fussell's grisaille of Eakins' students dissecting the body of a horse was actually the basis of an illustration to an article on the new mode of teaching at the Pennsylvania Academy ⊰pl. 84⊱. That same article quotes Eakins' disapproval of "long study of casts, even of the sculptors of the best Greek period." The danger, he said, was that the student "gets to fancying that all nature is run in the Greek mold."[8] Eakins, the anatomist, preferred drawing from the life. His pencil study of crossed legs seems to penetrate to the bone and tendon under the flesh and blood and skin ⊰pl. 87⊱. The absorption of the *trompe l'œil* painter with the construction of the object is paralleled here by Eakins. Indeed, Eakins would lavish as much attention on the man made artifact as on man's body. Even more intently than Chalfant, Eakins would recreate in paint the wooden shell of a violin. In Eakins' rendering of a nude woman ⊰pl. 36⊱ we become aware of the exterior as a projection of the structure underneath. The primary reality is the interior of the body, and the outer contours thus strike us as merely momentary dependent responses to the flexure of the skeleton. This was not the case earlier in the century. Our eyes immediately fasten onto the surface of hands drawn by Allston or a nude drawn by Greenough ⊰pls. 5, 25, and 35⊱. It was the surface of the object that articulated the affective qualities of form and action. This was why Allston and Greenough had stressed continuity of contour. In contrast, Eakins conceived of form and action not as psychological effect, but as revelation of structure and organization. Hence the contours of his figures become discontinuous, enabling our mind's eye to penetrate the surface. In the Romantic period the artist had conceived of movement as "expression." Now, Eakins was to conceive of movement as "function." In the spiritual collapse that followed the Romantic period, Eakins, almost in desperation, sought reality in the physical operation—making visible the invisible operation of his mind which itself was nothing but conscious protoplasm.

SHIPS AND THE RATIONALIZATION OF FORM

While Church represents an earlier synthesis of art and science there are also anticipations in his work of the functional aesthetic that is so persistently implied in Eakins. If one subtracts the spiritual mystique from Church's studies in the Arctic Seas in 1859, there remains an intense fascination with process ⊰pls. 24 and 49⊱. Absolutely uninfluenced by man, icebergs were among the earth's purest

[7] A most striking example of an "un-drama" by Homer would be *Snap the Whip,* of which he painted several versions in the 1870's. The action is not to be explained dramatically, as it would be in Allston's *The Feast of Belshazzar* or Mount's *The Dance of the Haymakers,* but functionally. Instead of Classical-Baroque resolution, there is disintegration as the chain of boys is pulled and ripped apart by centrifugal force. The movement is thus physically rather than psychologically expressive. A parallel development was taking place in architecture. Architects came to conceive of "expression" less as the gesture of the human spirit acted out in matter than as the articulation of the forces acting upon matter. Another symptom of Homer's post-anthropocentric set of mind at this early date is his frequent employment of a shifting, or sliding, or sloping ground plane over which he has his viewer stand or hover momentarily. Homer was boldly abandoning the stable, permanent, unified view of the Renaissance tradition. Small wonder that he would have found the world of the floating eye of the Japanese print so congenial. It pictured the flux of his own world view.

[8] W. C. Brownell, "The Art Schools of Philadelphia," *Scribner's Monthly Illustrated Magazine,* XVIII (September, 1879), pp. 741–42.

and most spectacular examples of the forces at work. It was essentially this same sensitivity to the action of the forces that manifested itself in the revolution which took place in ship building in the 1840's and '50's. To appreciate the nature of this revolution one should first glance at the design of some earlier ships. The sailboat and the packet ship *Washington* which appear in a painting of New York Harbor dating from the 1830's ⊰pl. 90⊱ look heavy, blunt and cumbersome alongside their conterparts in Buttersworth's renderings of the *Yacht America Leaving Boston Harbour* and *The Clipper Ship Great Republic* ⊰pls. 91 and 23⊱. It should be remembered that Donald McKay was the designer and builder of the latter. Southworth and Hawes photographed him ⊰pl. 10⊱ at the height of his reputation. Their portrait captures the drive and vision of one of the great innovators in naval architecture of the mid-century. Studying the behavior of water and air much as Church later studied it, McKay strove in experiment after experiment for optimum efficiency in the design of the hull and the rigging. It was the discipline of this quest that produced the perfectly rationalized form of that perfect man made creature of the forces, the clipper ship. In McKay's drawing for the *Lightning* ⊰pl. 88⊱ there is nothing of the decorative logic of Gibbs' penmanship or the emotional involvement of Cole's draughtsmanship to com-

promise the exigencies of nature. No bumps or contours in the half-model of the *Great Republic's* hull are introduced to appeal to the phrenologist or the poet ⊰pl. 25⊱. The drawing and the model preach no moral and illustrate no passion. Still, the hull is a beautiful and expressive form. It has graceful, pleasing lines; it appears to advance boldly and cut cleanly. As an object suggestive of motion it is even kin to the Belter style chair illustrated in plate 63. But while the motion in the chair expresses nothing but caprice, that in the hull expresses nothing but natural logic. The design of the *Great Republic* has its true counterparts in those vernacular objects, so instinct with movement, that Mount so ingeniously employed ⊰see, for example, pls. 2 and 66⊱. The most specific parallel in the exhibition, however, is the punt in Ranney's *Duck Hunters* ⊰pl. 70⊱. Though less elegant than McKay's hulls, this unpretentious vessel has a simple kindred beauty and expression. The Romantic attitude towards form, in its non-eclectic, non-literary manifestations was actually congenial to the functional aesthetic. Hence Shaker design, board and beam architecture, Church's sketches of icebergs, and McKay's clipper ships all may rightly be regarded as progressive tendencies of the mid-century which lead on ultimately to twentieth-century functionalism.

GREENOUGH: FUNCTIONALISM A LA THE APOLLO

One artist, Horatio Greenough, who has already been discussed in several quite different contexts, was actually our first major prophet of the modern aesthetic. Since he more than any other artist living in the Romantic period was able to verbalize a way of thinking that later matured with Louis Sullivan and Frank Lloyd Wright, it is fitting to conclude this essay with Greenough's forward look into the twentieth century.

Greenough said: "I define Beauty as the promise of Function; Action as the presence of Function; Character as the record of Function."[9] It was a new aesthetic dispensation, one strikingly at variance

with that of a Washington Allston or a Thomas Cole, even if it was actually directed at form in architecture and the applied arts. Greenough ridiculed Upjohn's Trinity Church: "the puny cathedral of Broadway, like an elephant dwindled to the size of a dog." We can be sure that most of Davis' designs in the exhibition would have withered under Greenough's eye and tongue. He had no tolerance for the conceits of Gothic. Chairs and stoves shaped to the whims of the genteel would have answered perfectly to this moralist's definition of "Fashion": "the instinctive effort of pretension to give by mere change the sensuous semblance of progress . . . a desperate effort to make a distinction out of nothing."

Still, as the products of his studio attest, Greenough, though he did not follow fashion, did follow

[9] All of the quotations from Greenough which follow have been taken from Harold Small (ed.), *Form and Function: Remarks on Art Design and Architecture by Horatio Greenough* (Berkeley and Los Angeles, 1962).

[27]

tradition. There is little, if anything in his *œuvre* that cannot, as we have seen, be accounted for within the schema of conventional aesthetics. Only in his regard for anatomy is his approach to his art significantly different from Allston's. Indeed, right up until the latter's death in 1843, Greenough looked for approval from his lifelong hero.

Greenough's drawings reflect the new functional aesthetic enunciated above far less frequently than they reflect the norms of his day: the concern with beauty as harmony of proportion, action as emotional state, character as expression of individuality. His words, in the abstract, sound modern: "there is no arbitrary law of proportion, no unbending model of form. . . . The law of adaptation is the fundamental law of nature in all structure." He argues that the animal kingdom, not the panoply of historic styles, is to be the model for an American democratic aesthetic. His are Adamic thoughts. However, Greenough's choices from nature betray the Neoclassicist: "The neck of the swan and that of the eagle, however different in character and proportion, equally charm the eye and satisfy the reason . . . The horse's shanks are thin, and we admire them; the greyhound's chest is deep, and we cry, beautiful!" As he argues the relativity of beauty, he cites neither the common pig, nor the rare wolverine. And though he introduces the camelopard as a dramatic example of adaptation, he does not proceed to discuss the beauty of this odd creature. To make his case, Greenough, without admitting it, directs the reader's attention to those animals which inspire the noblest associations and conform most closely to classical ideals. Hence he chooses the king of birds to bear the burden of his thesis:

Behold the eagle as he sits on the lonely cliff, towering high in the air; carry in your mind the proportions and lines of the dove and mark how the finger of God has, by the mere variation of diameters, converted the type of meekness into the most expressive symbol of majesty. His eye, instead of rushing as it were out of his head, to see the danger behind him, looks steadfastly forward from its deep cavern, knowing no danger but that which it pilots. The structure of his brow allows him to fly upward with his eyes in shade. In his beak and his talons we see at once the belligerent, in the vast expanse of his sailing pinions the patent of his prerogative. *Dei Gratia Raptor*. Whence the beauty and majesty of the bird? It is the oneness of his function that gives him his grandeur, it is transcendental mechanism alone that begets his beauty.

And so it was that in a design for the throne for the Washington statue Greenough considered the formal and associative properties of the eagle, dolphin, gryphon, and lion {pl. 89}. It was a conventional exercise in gradations of delicacy and strength in quality of form, as well as a testing of established symbols. He may have regarded the dolphin inappropriately weak, the lion leg too emphatic. He was obviously experimenting with motifs of *le style empire*. Later he recanted of "that French air which sinned" in this drawing.

There seems to have been an unresolved tension in Greenough—a tension between the strictly functional and the spiritually expressive. He tried to reconcile his admiration for Greece with his Puritan, or rather Transcendentalist, devotion to nature with the rationalization: "I contend for Greek principles, not Greek things." Greenough sought for those principles in the study of Greek art. While Eakins conceded that some knowledge of the human body might be derived from Greek sculpture, he would hardly have examined the sculpted *Horse of Selene* in the same spirit as did Greenough {pls. 86 and 87}. The Yankee sculptor, in his drawing of the famous equine head, was obviously looking for something that transcended the purely scientific. Greenough captured a nobility of expression in the beast, something of that same strength and vitality that he also discerned in Houdon's Washington {pl. 32}. There must, indeed, have been an element of Olympian transcendence in this fragment of the Parthenon. His remark on the sculptures of the Doric temple reveals the essence of his thought: "they took possession of the worshiper as he approached, lifted him out of everyday life, and prepared him for the presence of the divinity within." Greenough was much closer here to his contemporaries, the Audubons, than he was to the secular-minded Thomas Eakins. The instinct to idealize was basic to Romantic art. So, too, Greenough's drawing of a greyhound partakes of the grace and elegance of the younger Audubons' deer {pls. 68 and 89}. In turn, Greenough's paean to the eagle, quoted above, catches the majesty and dignity of "The Bird of Washington" much as John James Audubon painted it {pl. 33}.

In the realm of technology Greenough adduced the same law of adaptation which he observed in nature: the machine "struggling and cumbersome

when newly invented, in time becomes the compact, effective and beautiful engine." Though he cites the steam engine as an example for his principle, his only vivid examples of technological beauty are the American horse carriage and the American sailing vessel. Many of his contemporaries would have had to be re-educated to be persuaded of the beauty of wheels, connecting rods and smoke stacks. (Dickens, for example, regarded such features of our riverboats as "sullen, cumbrous, ungraceful.") Greenough thus wisely, perhaps unconsciously, pursued the same strategy which he pursued in discussing the design of animals. He chose forms that could not fail to score high in orthodox aesthetic points. Hence he presents to our mind's eye "the slender harness and tall gaunt wheels" of the wagon, qualities of lightness, delicacy and attenuation that aestheticians from Edmund Burke to Archibald Alison would have identified with "Beauty." And of the ship at sea Greenough exclaims: "Mark the majestic form of her hull as she rushes through the water, observe the graceful bend of her body, the gentle transition from round to flat, the grasp of her keel, the leap of her bows, the symmetry and rich tracery of her spars and rigging, and those grand wind muscles her sails. . . . What academy of design, what research of connoisseurship, what imitation of the Greeks produced this marvel of construction?" The trotting wagon and the yacht *America,* claimed the sculptor, were "nearer to Athens" than those who would "bend the Greek temple to every use." There was as much of Greece in these achievements of American technology as there was in Greenough's perceptions of the horse, the eagle, and the greyhound. But would he have said the same of Dickens' riverboat any more than he would have said the same of Barnum's camelo-

pard? One only need compare two or three drawings by the sculptor with the work of McKay or with Buttersworth's portraits of *The Great Republic* and *The Yacht America* to appreciate how much of the anatomical organization, the beauty of form, and nobility of action of man's body was reflected in the clipper ship and the racing yacht {pls. 23, 25, 86, 88, and 91}.

Unlike his twentieth-century heir, Frank Lloyd Wright, who emulated exotic and primitive art, Greenough could not discard the ideals of humanistic art. Religious bias and the aesthetic of Neoclassicism were too deeply ingrained in him. "The most beautiful organization of earth," said the sculptor,

is the human frame: touching earth with only one-half the soles of its feet—it tells of majesty and dominion by that upreared spine, of duty by those unencumbered hands. Where is the ornament of this frame? It is all beauty, its motion is grace, no combination of harmony ever equalled, for expression and variety, its poised and stately gait, its voice is music, no cunning mixture of wood and metal ever did more than feebly imitate its tone of command or its warble of love. The savage who envies or admires the special attributes of beasts maims unconsciously his own perfection to assume their tints, their feathers, or their claws; we turn from him with horror, and gaze with joy on the naked Apollo.

Greenough did anticipate the modern aesthetic: "Form Follows Function." True. But, ironically, it was the *Apollo* {pl. 10}, that classical archetype of beauty of human form and spirit, that pointed the way. It was doubly ironic that the form and spirit of the mythical god would eventually have to flee the artist's mind before the new aesthetic could be born. And with the flight of the god there vanished also the form of the excited spirit.

* * * * * * * *

In writing an essay for an exhibition of such a wide-ranging nature it was necessary to consult a miscellany of sources that numbers in the hundreds. As it is impossible to list the authors, let alone the titles, of all the bibliographical items that contributed to the research for the exhibition and essay, I shall have to count on the indulgence of all those living and dead to whom I am indebted on this occasion and apologize for omitting specific reference to them. Indeed, there is only space to ac-

knowledge by name a handful of students of nineteenth-century American art and culture whose works have been of especial value in the preparation of this manuscript:

John I. H. Baur; Wells I. Bennett; Peter Bermingham; E. Maurice Bloch; Russell Burke; Joseph T. Butler; Nicolai Cikovsky, Jr.; Mary Bartlett Cowdrey; Wayne Craven; Jane B. Davies; Edward H. Dwight; Stuart P. Feld; Marvin Felheim; James Thomas Flexner; Alfred Frankenstein; Al-

bert Ten Eyck Gardner; William H. Gerdts; Lloyd Goodrich; Alan Gowans; Francis Grubar; Neil Harris; Louis Hawes; Gordon Hendricks; John Higham; John Howat; John A. Kouwenhoven; Oliver W. Larkin; David Lawall; John W. Mc-Coubrey; Garnett McCoy; Howard S. Merritt; Barbara Novak; Elwood Parry; John Pearce; Jules D. Prown; Edgar P. Richardson; Theodore E. Stebbins, Jr.; William Talbot; William Truettner; John Wilmerding; Nathalia Wright; Richard P. Wunder.

Also, there are many who, as students in my courses or as research assistants, made useful contributions. I should like to thank in particular, Christopher Campbell, Susan Clarke, Donald Clausing, Nancy Davison, Susan Fingeret, Adrienne Kaplan, Catherine Lambert, Charles Moore, Curt Rasek, Janice Schimmelman, Patricia Siemon, and Eric Turetsky. Mrs. Doris Borthwick deserves particular recognition for weeks on end of hard and devoted work. And to Edward Molnar for his role in the critical task of writing letters and travelling in quest of objects I am especially indebted. For months he was available to act on my every wish and, always with tact, was ready to prod and goad me.

Finally, this exhibition, which might better have been entitled "Art and Pandora's Box," could never have come into being without the long-suffering and whole-hearted cooperation of the entire staff of The University of Michigan Museum of Art. I should like to thank especially Robert Yassin, Acting Associate Director, who as editor involved himself diligently with the countless details of this publication and acted as my *alter ego* in the preparation of the manuscript. And, last of all, I welcome this opportunity to express my gratitude to Charles Sawyer, the director, for his infinite patience and unstinting support, and for his wisdom, which, like a benign spirit, presided over each of the successive phases of the exhibition rather like the angel in a somewhat similar sequel of trial of the spirit, Thomas Cole's *The Voyage of Life*.

Catalogue of the Exhibition.

In the following catalogue objects have been divided into four groups: 1) Paintings, Drawings, Prints, Photographs; 2) Sculptures; 3) Miscellaneous Related Materials (arranged by type of material); 4) Books. Within these groups objects are arranged alphabetically by artist or author. Dimensions are given in inches, height preceding width unless otherwise indicated.

PAINTINGS, DRAWINGS, PRINTS, PHOTOGRAPHS

FRANCIS ALEXANDER (1800–1881)

1 〈plate 12〉
Daniel Webster (Black Dan), 1835
Oil on canvas, 30 x 25
Lent from the Dartmouth College Collection, Gift of Dr. George C. Shattuck, Class of 1803

WASHINGTON ALLSTON (1779–1843)

2 〈plate 7〉
The Evening Hymn, 1835
Oil on canvas, 25 x 23
Lent by the Montclair Art Museum, Gift of Mr. and Mrs. H. St. John Webb, 1961

3 〈plate 3〉
Study for the Feast of Belshazzar, 1817
Oil on millboard, 30 1/4 x 25
Lent by the Museum of Fine Arts, Boston, Bequest of Ruth Charlotte Dana

4 〈plate 14〉
Head of a Jew, 1817
Oil on canvas, 30 1/4 x 25
Lent by the Museum of Fine Arts, Boston, Gift of Henry Copley Greene

5 〈plate 43〉
Angel and Peter, c. 1812
Pencil on blue paper, 6 1/2 x 6 1/4
Lent by the Museum of Fine Arts, Boston, Gift of the Allston Trust, by exchange

6 〈plate 17〉
Portrait Study: Profile of a Man
Chalk heightened with white on blue paper, 6 7/8 x 4 11/16
Lent by the Washington Allston Trust, Fogg Art Museum, Harvard University

7 〈plate 17〉
Female Head
Chalk heightened with white on tan paper, 11 1/16 x 11 1/16
Lent by the Washington Allston Trust, Fogg Art Museum, Harvard University

8 〈plate 5〉
Left Hand of Belshazzar
Crayon heightened with white on blue paper, 9 1/2 x 12 7/16
Lent by the Washington Allston Trust, Fogg Art Museum, Harvard University

9 〈plate 25〉
Man's Hand
Chalk heightened with white on dark tan paper, 5 7/16 x 8 7/8
Lent by the Washington Allston Trust, Fogg Art Museum, Harvard University

10 〈plate 25〉
Hand
Chalk heightened with white on tan paper, 7 13/16 x 9 7/8
Lent by the Washington Allston Trust, Fogg Art Museum, Harvard University

11 {plate 5}
Hand and Forearm
Pencil and chalk on blue paper, 12 1/8 x 9 7/8
Lent by the Washington Allston Trust, Fogg Art Museum, Harvard University

JOHN JAMES AUDUBON (1785–1851)

12 {plate 33}
The Eagle of Washington, 1837
Oil on canvas, 48 x 36
Lent by Mr. and Mrs. S. Dillon Ripley and Mrs. Gerald M. Livingston

VICTOR G. AUDUBON (1809–1860)
(attributed to) and
JOHN W. AUDUBON (1812–1862)
(attributed to)

13 {plate 68}
Startled Deer—A Prairie Scene, c. 1848
Oil on canvas, 37 3/4 x 60
Lent by The Brooklyn Museum, Gift of A. B. Baylis

JOHN JAMES BARRALET (c. 1747–1815)

14 {plate 30}
Commemoration of Washington
Colored engraving, 24 x 18 5/8
Lent by the William L. Clements Library, The University of Michigan

WILLIAM H. BEARD (1824–1900)

15 {plate 80}
Susanna and the Elders, 1865
Oil on canvas, 15 1/4 x 21
Lent by Henry Melville Fuller, New York

GEORGE CALEB BINGHAM (1811–1879)

16 {plate 26}
The County Election, 1851–52
Oil on canvas, 35 7/16 x 48 3/4
Lent by The St. Louis Art Museum

17 {plate 4}
Two Citizens Conversing (study for *The County Election*), 1851–52
Pencil, brush and gray wash, 11 1/2 x 9 1/4
Lent by The St. Louis Mercantile Library Association

18 {plate 1}
Two Citizens (study for *The County Election*), 1851–52
Pencil, brush and gray ink, 13 3/4 x 10 1/8
Lent by The St. Louis Mercantile Library Association

19 {plate 4}
Early Celebrants (study for *The County Election*), 1851–52
Pencil, brush and gray wash, 11 1/8 x 9
Lent by The St. Louis Mercantile Library Association

20 {plate 19}
Intoxicated Citizen (study for *The County Election* (?)), 1851–52
Pencil, brush and gray wash, 10 1/8 x 8 1/2
Lent by The St. Louis Mercantile Library Association

21 {plate 10}
Hearty Drinker (study for *The County Election*), 1851–52
Pencil, brush and gray wash, 11 3/8 x 9 1/8
Lent by The St. Louis Mercantile Library Association

KARL BODMER (1809–1893)

22 {plate 39}
The Bunker Hill Monument on Breed's Hill near Boston as It Was in the Year 1832, 1832
Watercolor, 6 3/8 x 8 5/8
Lent by the Northern Natural Gas Company Collection, Joslyn Art Museum

[32]

W. VAN DE VELDE BONFIELD (active 1860's)

23 {plate 50}
Drifting Snow
Oil on canvas, 16 1/8 x 24 1/8
Lent by The University of Michigan Museum of
Art, Gift of Miss Isabelle Stearns, 1943

ELIPHALET BROWN (1816–1886) and
CHARLES SEVERIN (active 1845–1860)

24 {plate 77}
Barnum's American Museum, 1851
Colored lithograph in black and light blue,
22 x 29 1/4
Lent by the New-York Historical Society

JAMES E. BUTTERSWORTH
[or BUTTERWORTH] (1817–1894)

25 {plate 23}
The Clipper Ship Great Republic, 1853
Oil on canvas, 17 1/2 x 23 1/4
Lent by the Peabody Museum of Salem

26 {plate 91}
Yacht America Leaving Boston Harbour, c. 1870
Oil on canvas, 20 x 30
Lent by the Museum of Art, Rhode Island School
of Design, Jesse Metcalf Fund

JAMES H. CAFFERTY (1818–1869) and
CHARLES G. ROSENBERG (active 1857–1866)

27 {plate 21}
A Painting of the Revulsion of 1857. Wall Street,
half past 2 o'clock. Oct. 13, 1857, 1858
Oil on canvas, 50 x 40
Lent by the Museum of the City of New York

JEFFERSON CHALFANT (1856–1931)

28 {plate 8}
Violin and Bow, 1889
Oil on canvas, 36 x 21 5/8
Lent by The Metropolitan Museum of Art, Pur-
chase, George A. Hearn Fund, 1966

THOMAS CHAMBERS (c. 1808–after 1866)

29 {plate 44}
Niagara Falls, c. 1820–40
Oil on canvas, 22 x 30 1/16
Lent by the Wadsworth Atheneum, The Ella Gallup
Sumner and Mary Catlin Sumner Collection

JOSEPH GOODHUE CHANDLER (1813–1880)

30 {plate 79}
Webster at Bunker Hill
Oil on canvas, 42 x 36
Lent from the Dartmouth College Collection

FREDERIC EDWIN CHURCH (1826–1900)

31 {plate 78}
Ossisuak
Oil on canvas, 23 x 17
Lent Anonymously

32 {plate 45}
Niagara [after the painting by Church], c. 1857
Chromolithograph touched with oil, 27 1/4 x 46 1/2
Lent by Olana Historic Site

33 {plate 24}
The Icebergs (The North) [print by C. Risdon after
a lost painting by Church], 1861 (date of painting)
Chromolithograph touched with oil, 21 x 35 3/4
Lent by Olana Historic Site

34 {plate 24}
Sketch of an Iceberg, 1859
Oil on paper, 16 x 22 (framed dimensions)
Lent by the Cooper-Hewitt Museum of Decorative Arts and Design, Smithsonian Institution, Gift of Louis P. Church

35 {plate 49}
Sketch of Icebergs, 1859
Oil on paper, 16 x 22 (framed dimensions)
Lent by the Cooper-Hewitt Museum of Decorative Arts and Design, Smithsonian Institution, Gift of Louis P. Church

36 {plate 49}
Sketch of an Iceberg, 1859
Oil on paper, 16 x 22 (framed dimensions)
Lent by the Cooper-Hewitt Museum of Decorative Arts and Design, Smithsonian Institution, Gift of Louis P. Church

37 {plate 72}
Sketches of Icebergs, 1859
Pencil and white gouache on blue-green paper, 16 x 22 (framed dimensions)
Lent by the Cooper-Hewitt Museum of Decorative Arts and Design, Smithsonian Institution, Gift of Louis P. Church

THOMAS COLE (1801–1848)

38 {plate 51}
The Departure, 1837
Oil on canvas, 39 1/2 x 63
Lent by the Corcoran Gallery of Art

39 {plate 69}
American Lake Scene, 1844
Oil on canvas, 18 1/4 x 24 1/4
Lent by The Detroit Institute of Arts, Gift of Douglas F. Roby

40 {plate 44}
Niagara Falls, c. 1829–30
Oil on wood panel, 15 3/4 x 24 1/4
Lent by the Galleries—Cranbrook Academy of Art

41 {plate 74}
View of the White Mountains, New Hampshire, 1827
Oil on canvas, 24 7/8 x 34 5/8
Lent by the Wadsworth Atheneum, Bequest of Daniel Wadsworth

42 {plate 58}
Sketch for "Manhood" from the series *The Voyage of Life*, c. 1839–40
Oil on canvas, 15 x 23
Lent by the Addison Gallery of American Art, Phillips Academy

43 {plate 37}
Ilissus or *Kefissos* (from West Pediment, Parthenon), 1841 or 1842
Pencil and crayon heightened with white on gray paper, 14 7/8 x 18 3/16
Lent by The Detroit Institute of Arts

44 {plate 60}
Ear and Grotesque Face
Pencil, 9 3/8 x 6 3/16
Lent by The Detroit Institute of Arts

45 {plate 61}
Grotesque Face (page 36, Sketchbook 6), 1831
Pencil, 7 1/8 x 4 1/2
Lent by The Detroit Institute of Arts

46 {plate 72}
Twilight Sky of a Melancholy Expression, 1845
Pen and brown ink and pencil on light blue paper, 5 1/16 x 7 7/8
Lent by The Detroit Institute of Arts

47 {plate 61}
Cliff Suggesting Man's Face (page 6, Sketchbook dated 1841), 1841
Pencil, 6 3/16 x 4 3/8
Lent by The Detroit Institute of Arts

48 {plate 37}
Gnarled Tree Trunk
Pen and brown ink, 15 3/8 x 10 5/8
Lent by The Detroit Institute of Arts

49 ⋅{plate 73}⋅
Studies of Tree Trunks, c. 1827
Pencil, 19 1/8 x 13 1/2
Lent by The Detroit Institute of Arts

50 ⋅{plate 61}⋅
Trunk of a Butternut Tree
Pencil, 6 1/4 x 10 1/8
Lent by The Detroit Institute of Arts

51 ⋅{plate 62}⋅
Shuddering Tree (page 55, Sketchbook 4)
Pencil, 7 7/16 x 4 9/16
Lent by The Detroit Institute of Arts

52 ⋅{plate 73}⋅
Landscape with Italian Villa and Trees
Pencil on tan paper, 16 1/4 x 11 9/16
Lent by The Detroit Institute of Arts

JASPER FRANCIS CROPSEY (1823–1900)

53 ⋅{plate 75}⋅
Mount Washington from Lake Sebago, Maine, 1871
Oil on canvas, 16 x 30
Lent by the Mint Museum of Art

54 ⋅{plate 62}⋅
Chestnut Tree, 1854
Pencil, 11 1/4 x 8 1/4
Lent by The University of Michigan Museum of Art

55
River Landscape
Pencil, 9 1/8 x 12 11/16
Lent by The University of Michigan Museum of Art

NATHANIEL CURRIER (1813–1888); J. FISHER (?)

56 ⋅{plate 41}⋅
View of Bunker Hill and Monument, c. 1843–46
Colored lithograph, 14 x 10 (size of sheet)
Lent from the Dartmouth College Collection

ALEXANDER JACKSON DAVIS (1803–1892)

57 ⋅{plate 53}⋅
The University of Michigan Project: Plan of Campus Set in Green Lawn
Watercolor, pen and ink over pencil, 13 3/8 x 16 1/8
Lent by The Metropolitan Museum of Art, Harris Brisbane Dick Fund, 1924

58 ⋅{plate 52}⋅
The University of Michigan Project: Study for Gothic Entrance, 1838
Watercolor, pen and ink over pencil, 25 3/4 x 17 5/8
Lent by The Metropolitan Museum of Art, Harris Brisbane Dick Fund, 1924

59 ⋅{plate 52}⋅
The University of Michigan Project: North Wing, 1838
Watercolor, pen and ink over pencil, 10 5/8 x 22 1/2 (size of drawing); 18 7/8 x 26 7/8 (size of sheet)
Lent by The Metropolitan Museum of Art, Harris Brisbane Dick Fund, 1924

60
Lyndhurst (Paulding/Merritt/Gould House): *West Elevation and Plan*, c. 1864–68
Watercolor, pen and ink over pencil, 13 x 11 3/4
Lent by The Metropolitan Museum of Art, Harris Brisbane Dick Fund, 1924

61 ⋅{plate 53}⋅
Lyndhurst (Paulding/Merritt/Gould House): *Elevation and Plans of Paulding House*, 1838
Watercolor, pen and ink over pencil, 7 3/4 x 10 3/4
Lent by The Metropolitan Museum of Art, Harris Brisbane Dick Fund, 1924

62 ⋅{plate 48}⋅
Lyndhurst (Paulding/Merritt/Gould House): *Elevation with Ground Plan Set in Landscape*, 1865
Watercolor, pen and ink over pencil, 18 3/4 x 26 3/4
Lent by The Metropolitan Museum of Art, Harris Brisbane Dick Fund, 1924

63 〈plate 65〉
Lyndhurst (Paulding/Merritt/Gould House):
Interior Perspective of Dining Room, 1837
Watercolor, pen and ink over pencil, 13 1/2 x 20 1/4
*Lent by The Metropolitan Museum of Art, Harris
Brisbane Dick Fund, 1924*

64 〈plate 48〉
*Preliminary Study for House of Mansions, 5th
Avenue: Front Elevation and Ground Plan,* 1858
Watercolor, pen and ink over pencil, 18 5/8 x 27
*Lent by The Metropolitan Museum of Art, Harris
Brisbane Dick Fund, 1924*

65 〈plate 38〉
Design for a Chapel in the Gothic Style, c. 1835
Watercolor, pen and ink over pencil, 17 1/2 x 12 7/8
(size of drawing); 28 3/4 x 17 1/2 (size of sheet)
*Lent by The Metropolitan Museum of Art, Harris
Brisbane Dick Fund, 1924*

66 〈plate 47〉
Monumental Cemetery Entrance in Egyptian Style,
c. 1830–35
Watercolor, pen and ink over pencil, 18 3/4 x 25 1/2
*Lent by The Metropolitan Museum of Art, Harris
Brisbane Dick Fund, 1924*

67 〈plate 38〉
Monumental Cemetery Entrance in Egyptian Style,
c. 1830–35
Watercolor, pen and ink over pencil, 18 1/4 x 23 1/2
*Lent by The Metropolitan Museum of Art, Harris
Brisbane Dick Fund, 1924*

THOMAS EAKINS (1844–1916)

68 〈plate 15〉
Portrait of William H. MacDowell
Oil on canvas, 24 x 20
*Lent by Yale University Art Gallery, Bequest of
Stephen Carlton Clark, B.A. 1903*

69 〈plate 36〉
Nude Woman Reclining, Back Turned, c. 1866
Charcoal on tan paper, 18 1/2 x 23 3/4
*Lent by the Philadelphia Museum of Art, Given by
Mrs. Thomas Eakins and Miss Mary D. Williams*

70 〈plate 87〉
Legs of Seated Model
Charcoal, 26 x 20
Lent from the Collection of The Newark Museum

71 〈plate 86〉
*Anatomical Drawing: Human Knee, Bone, Horse's
Head,* 1878
Pencil and pen and ink on blue-lined paper, 14 x 19
Lent by the Joseph H. Hirshhorn Collection

72 〈plate 10〉
William H. MacDowell
Photograph (facsimile)
*Lent by The Metropolitan Museum of Art, David
Hunter MacAlpin Fund, 1943*

73 〈plate 82〉
Eakins Dog—Nance
Photograph (facsimile)
Lent by the Joseph H. Hirshhorn Collection

CHARLES FENDERICH
(active c. 1830–after 1870)

74 〈plate 14〉
John Calhoun, 1837
Lithograph, 12 3/8 x 10 1/16
*Lent by the National Portrait Gallery, Smithsonian
Institution*

75 〈plate 39〉
*Design of the National Washington Monument by
Robt. Mills of S.C. Archt.,* 1846
Lithograph, 23 x 17
Lent by the Library of Congress

JOHN FORSYTH (active 1845–1849) and
E. W. MIMÉE (active c. 1847)

76 〈plate 42〉
Birdseye View of Trinity Church, 1847
Lithograph, 19 3/4 x 15 3/4
Lent by The New-York Historical Society

CHARLES LEWIS FUSSELL (1840–1909)

77 ⊰plate 84⊱
Academy Students Dissecting a Horse, 1879
Monochrome oil on cardboard, 7 1/4 x 10 1/4
Lent by the Pennsylvania Academy of the Fine Arts

J. M. GIBBS (?)

78 ⊰plate 71⊱
The Chase, c. 1850
Pen and ink, 29 7/8 x 49 5/8
Lent by Hirschl and Adler Galleries, New York

HORATIO GREENOUGH (1805–1852)

79 ⊰plate 35⊱
Borghese Mars (Roman Sketchbook, no. 15), 1826
Pen and brown ink over pencil, 9 1/2 x 7 1/2
Lent by Miss Nathalia Wright

80 ⊰plate 35⊱
Nude Man, Front (Petit Sully Collection, no. 17), 1830
Pencil, 18 x 12 1/2
Lent by Miss Nathalia Wright

81 ⊰plate 88⊱
Study of Musculature of Legs and Torso of Nude Man (Petit Sully Collection, no. 48), 1832
Pencil, 15 1/2 x 9 7/8
Lent by Miss Nathalia Wright

82 ⊰plate 86⊱
Anatomical Study of a Leg (Petit Sully Collection, no. 47), 1832
Pencil, 17 1/2 x 11 3/4
Lent by Miss Nathalia Wright

83 ⊰plate 30⊱
Head of Washington (Roman Sketchbook, no. 32, detail), 1826–27
Pencil, 9 1/2 x 7 1/2
Lent by Miss Nathalia Wright

84 ⊰plate 28⊱
Head of Washington (Petit Sully Collection, no. 55), 1832–36
Pencil, 14 3/8 x 9 1/2
Lent by Miss Nathalia Wright

85 ⊰plate 28⊱
Head of Washington (Petit Sully Collection, no. 56), 1832–36
Pen and brown ink and pencil, 14 3/4 x 9 1/2
Lent by Miss Nathalia Wright

86 ⊰plate 32⊱
Head of Washington after Houdon (Petit Sully Collection, no. 62), 1834
Pen and ink and pencil, 14 x 11
Lent by Miss Nathalia Wright

87 ⊰plate 34⊱
Pedestal for "Washington" (Petit Sully Collection, no. 85), 1841–43
Pen and brown ink, 15 1/2 x 9 7/8
Lent by Miss Nathalia Wright

88 ⊰plate 34⊱
Studies for the Statue of Washington (detail) (Petit Sully Collection, no. 43 verso), 1832
Pen and brown ink over pencil, 19 x 13 1/4
Lent by Miss Nathalia Wright

89 ⊰plate 89⊱
Designs for the Chair of the Washington Statue (Petit Sully Collection, no. 53 verso), 1832–33
Pen and brown ink over pencil, 16 3/8 x 11 7/8
Lent by Miss Nathalia Wright

90 ⊰plate 89⊱
Infant's Head; Woman's Head; Draped and Helmeted Figure; Head of Samuel F. B. Morse; Man's Head; Greyhound; Boy's Head: "A Promising Lad"; Nude Woman, Rear; Lafayette [?]; Nude Man; Head of Albert Brisbane; Head of Woman with Tiara; Nose and Lines; Ear (Petit Sully Collection, no. 20), 1831
Pen and brown ink, 15 3/4 x 9 3/4
Lent by Miss Nathalia Wright

[37]

91 ⟨plate 87⟩
Horse of Selene from the Parthenon Pediment,
Left Corner (Petit Sully Collection, no. 44), 1832
Pencil, 25 1/2 x 18
Lent by Miss Nathalia Wright

ISAAC HAYES (1832–1881) and
WILLIAM BRADFORD (1823?–1893)

92
Castle Iceberg in Melville Bay (from the
photographic portfolio *Arctic Regions*), 1869
Sepia photograph, 17 x 21 1/8
Lent by Olana Historic Site

GEORGE P. A. HEALY (1813–1894)

93 ⟨plate 15⟩
Portrait of Daniel Webster, 1852
Oil on canvas, 30 x 25
Lent by the Pennsylvania Academy of the Fine Arts,
John Frederick Lewis Memorial Collection

EDWARD HICKS (1780–1849)

94 ⟨plate 76⟩
The Peaceable Kingdom, c. 1830–40
Oil on canvas, 17 1/2 x 23 11/16
Lent by the Worcester Art Museum

WINSLOW HOMER (1836–1910)

95 ⟨plate 93⟩
The New England Country School, 1872
Oil on canvas, 12 x 18
Lent by the Addison Gallery of American Art,
Phillips Academy

96 ⟨plate 92⟩
Girl (Adelaide Cole), 1879
Pencil on illustration board, 10 x 9 3/8
Lent by The University of Michigan Museum of
Art, Margaret Watson Parker Bequest

WILLIAM MORRIS HUNT (1824–1879)

97 ⟨plate 45⟩
Niagara Falls, c. 1878
Oil on canvas, 28 x 23 7/8
Lent by the Smith College Museum of Art

98 ⟨plate 9⟩
Young Woman with a Guitar [attributed to Hunt]
Oil on canvas, 29 3/4 x 20 1/2
Lent by the Pennsylvania Academy of the Fine Arts

HENRY INMAN (1801–1846)

99 ⟨plate 13⟩
William C. Macready, c. 1827
Oil on canvas, 30 1/4 x 25
Lent by The Metropolitan Museum of Art, Purchase,
Rogers Fund, 1909

GEORGE INNESS (1825–1894)

100 ⟨plate 50⟩
Sunnyside, 1847 (after)
Oil on canvas, 14 3/4 x 19 3/4
Lent by Sleepy Hollow Restorations

DANIEL WRIGHT KELLOGG (1807–1874)
[D. W. KELLOGG & CO.]

101 ⟨plate 66⟩
Shakers, Their Mode of Worship, c. 1840
Colored lithograph, 13 1/4 x 16 1/4 (framed
dimensions)
Lent by The Shaker Museum

DONALD McKAY (1810–1880)

102 ⟨plate 88⟩
Original Plan of the Lines and Sail Plan of the
Clipper Ship "Lightning," 1853
Pen and blue and red ink, 14 x 45
Lent by the Peabody Museum of Salem

WILLIAM SIDNEY MOUNT (1807–1868)

103 {plate 6}
Banjo Player, c. 1855
Oil on canvas, 25 x 30
Lent by The Detroit Institute of Arts, Gift of Dexter M. Ferry, Jr.

104 {plate 22}
California News, 1850
Oil on canvas, 21 1/8 x 20 1/4
Lent by the Suffolk Museum & Carriage House at Stony Brook, L.I., Melville Collection

105 {plate 2}
The Dance of the Haymakers, 1845
Oil on canvas, 25 x 30
Lent by the Suffolk Museum & Carriage House at Stony Brook, L.I., Melville Collection

106 {plate 81}
Ringing the Pig, 1842
Oil on canvas, 24 1/2 x 29 1/2
Lent by the New York State Historical Association

107 {plate 43}
The Power of Music; The Dance of the Haymakers (two studies on one sheet), c. 1845
Pencil, 8 7/8 x 5 1/2
Lent by the Suffolk Museum & Carriage House at Stony Brook, L.I., Melville Collection

108 {plate 16}
Drawings from Hogarth's Heads
Pencil, 9 3/4 x 8 3/4
Lent by the Suffolk Museum & Carriage House at Stony Brook, L.I., Melville Collection

109 {plate 18}
Mr. Kean as Coriolanus
Pencil, 5 1/2 x 3 15/16
Lent by the Suffolk Museum & Carriage House at Stony Brook, L.I., Melville Collection

110 {plate 18}
Henry S. Mount on His Death Bed, 1841
Watercolor, pen and brown ink, 10 x 8
Lent by Mr. and Mrs. Theodore E. Stebbins, Jr.

111 {plate 66}
Drawings for Mount House Kitchen
Pencil, 4 1/2 x 5 3/4
Lent by the Suffolk Museum & Carriage House at Stony Brook, L.I., Melville Collection

JAMES PEALE (1749–1831)

112 {plate 57}
Still Life: Fruit
Oil on canvas, 16 x 22
Lent from the Collection of The Newark Museum

REMBRANDT PEALE (1778–1860)

113 {plate 14}
Portrait of John Calhoun, 1838
Oil on canvas, 30 1/4 x 25 1/8
Courtesy of the Carolina Art Association

114 {plate 31}
Washington before Yorktown, 1850
Monochrome oil on canvas, 23 3/4 x 19 1/2
Lent by The Dietrich Brothers Americana Corporation, Philadelphia

ALEXANDER POPE (1849–1924)

115 {plate 83}
The Trumpeter Swan, 1911
Oil on canvas, 57 1/4 x 43 3/4
Lent by Meredith Long and Company, Houston, Texas

JOHN QUIDOR (1801–1881)

116 ⊰plate 67⊱
Wolfert's Will, 1856
Oil on canvas, 27 x 34
Lent by The Brooklyn Museum, Dick S. Ramsay
Fund

WILLIAM TYLEE RANNEY (1813–1872)

117 ⊰plate 70⊱
Duck Hunters, 1849
Oil on canvas, 26 x 40
Lent by the Museum of Fine Arts, Boston, Gift of
Maxim Karolik

RAPHAEL (1483–1520)

118 ⊰plate 16⊱
He Was Transfigured before Them [print by
H. Robinson after Raphael's *Transfiguration*],
19th c.
Engraving, 8 3/8 x 5 3/4
Lent by Olana Historic Site

SEVERIN ROESEN (?–1871)

119 ⊰plate 57⊱
Still Life, c. 1850–55
Oil on canvas, 19 3/4 x 15 3/4
Lent from the Collection of Jo Ann and Julian
Ganz, Jr.

PETER FREDERICK ROTHERMEL
(1817–1895)

120 ⊰plate 27⊱
United States Senate [print by Butler and Long
after Rothermel], c. 1850–51
Engraving, 34 x 40
Lent from the Dartmouth College Collection

ALBERT S. SOUTHWORTH (1811–1894)
and JOSIAH J. HAWES (1808–1901)

121 ⊰plate 29⊱
Daniel Webster, 1850
Daguerreotype, 7 1/8 x 5 5/8
Lent from the Dartmouth College Collection, Gift of
Josiah J. Hawes and Albert S. Southworth

122 ⊰plate 10⊱
Donald McKay, 1855
Daguerreotype (facsimile)
Lent by The Metropolitan Museum of Art

GILBERT STUART (1755–1828)

123 ⊰plate 30⊱
Portrait of George Washington (The Allibone
Portrait)
Oil on canvas, 29 1/4 x 24 1/4
Lent by the Cincinnati Art Museum, Bequest of
Mrs. Mary M. Emery

THOMAS SULLY (1783–1872)

124 ⊰plate 19⊱
The Rosebud, 1841
Oil on canvas, 23 7/8 x 36 1/2
Lent by The Metropolitan Museum of Art, Bequest
of Francis T. S. Darley, 1914

HANNA ANN TREADWAY (mid 19th c.)

125 ⊰plate 59⊱
Holy Mother Wisdom to Hanna Ann Treadway,
1845
Pen and blue ink with touches of red wash and blue
wash, 15 x 20 1/2
Lent by the Philadelphia Museum of Art, Given by
Mr. and Mrs. Julius Zieget

JOHN TRUMBULL (1756–1843)

126 {plate 40}
Battle of Bunker Hill [engraved by Johann Gotthard
von Müller after the painting by Trumbull], 1798
Engraving, 23 x 31 1/4 (plate size)
*Lent by the William L. Clements Library, The
University of Michigan*

UNKNOWN

127 {plate 90}
New York Harbor, Boats, Ship, Round Fort,
c. 1836–38
Oil on canvas, 26 x 38
Lent by Kennedy Galleries, Inc., New York

128 {plate 46}
Mourning Picture, 1830
Watercolor, 20 x 26 1/2
Lent by Robert Bishop

129 {plate 10}
Apollo Belvedere, 19th c.
Sepia photograph, 14 1/4 x 9 1/4
Lent by Olana Historic Site

130 {plate 55}
Advertisement for "H. Purves Stove Co.,"
mid 19th century
Lithograph, 23 1/4 x 18
*Lent by the New-York Historical Society, from the
Bella C. Landauer Collection*

CHARLES WIMAR (1828–1862)

131 {plate 20}
The Attack on an Emigrant Train, 1856
Oil on canvas, 55 1/4 x 79
*Lent by The University of Michigan Museum of
Art, Bequest of Henry C. Lewis*

SCULPTURES

THOMAS BALL (1819–1911)

132 {plate 11}
Daniel Webster, 1853
Bronze, 28 1/4 h.
*Lent by The Detroit Institute of Arts, Laura H.
Murphy Fund*

THOMAS EAKINS (1844–1916)

133 {plate 84}
Horse Skeleton, 1878
Plaster relief, 11 1/8 x 14 3/8
*Lent by The University of Michigan Museum of
Art, Gift of Wilfred B. Shaw*

134 {plate 85}
The Mare "Josephine" Écorché, 1882
Plaster relief partly painted, 23 1/4 x 32 1/2
*Lent by The University of Michigan Museum of
Art, Gift of Wilfred B. Shaw*

HIRAM POWERS (1805–1873)

135 {plate 12}
Bust of Daniel Webster, 1837 (?)
Marble, 23 x 14 1/2 x 9 d.
Lent by the Boston Athenaeum

RANDOLPH ROGERS (1825–1892)

136 {plate 32}
Bust of George Washington, 1868
Marble, 32 h.
*Lent by The University of Michigan Museum of
Art, Bequest of Henry C. Lewis*

MISCELLANEOUS RELATED MATERIALS

DONALD McKAY (1810–1880)

137 {plate 25}
Great Republic, c. 1853
Ship half model in wood
Lent by the Museum of Fine Arts, Boston

E. F. CHAPMAN (attributed to)

138 {plate 13}
Phrenological Head, mid 19th century
Porcelain
Lent by Dr. and Mrs. Irving F. Burton

UNKNOWN

139 {plate 29}
Phrenological Head, 1850–59
Graniteware, 5 1/2 x 2 7/8 x 3 1/4 d.
Lent by Mr. and Mrs. Charles V. Hagler

140 {plate 28}
Eagle, c. 1865–85
Cast iron, 17 x 48 x 24 d.
*Lent from the Collections of the Henry Ford
Museum*

141 {plate 56}
Chair (John Henry Belter, 1804–1863), c. 1850
Laminated rosewood, 42 x 22 x 21 d.
*Lent from the Collection of Steven and Jenay
Katkowsky*

142 {plate 64}
Chair, c. 1850
Laminated wood, 38 x 16 1/2 x 21 d.
*Lent from the Collections of the Henry Ford
Museum*

143 {plate 63}
Chair, c. 1850
Walnut, 41 1/2 x 18 3/4 x 18 1/2 d.
*Lent from the Collections of the Henry Ford
Museum*

144 {plate 64}
Shaker Side Chair (Mount Lebanon, New York),
c. 1860
Maple, No. 4 size, 33 3/4 x 21 3/4 x 18 1/8 d.
Lent by Mr. and Mrs. Kenneth E. Brooker

145
Shaker Oval Box with Cover (probably from
Alfred, Maine), 19th century
Maple sides, butternut (?) top and bottom,
6 x 4 1/8 x 2 1/4 d.
Lent by The Shaker Museum

146 {plate 54}
Shaker Box Stove (probably Shaker Community,
New York), c. 1850
Cast iron, 19 x 13 x 29 d.
*Lent from the Collections of the Henry Ford
Museum*

147 {plate 54}
Parlor Heating Stove (E. Huntington, Elmira,
New York), 1847
Cast iron, 29 x 26 1/2 x 17 1/2 d.
*Lent from the Collections of the Henry Ford
Museum*

148 ·{plate 54}·
Upright Parlor Heating Stove (Samuel D. Vose &
Co., Albany, New York), 1854
Cast iron, 44 x 21 x 28 d.
*Lent from the Collections of the Henry Ford
Museum*

149
Pane of Glass (Bakewell and Co.), c. 1840–50
Glass, 7 x 4 7/8 x 3/8 d.
*Lent from the Collections of the Henry Ford
Museum*

150
Winter Tree; Summer Tree, mid 19th century
Glass flask, 7 1/2 x 5 x 2 d.
*Lent from the Collections of the Henry Ford
Museum*

151 ·{plate 40}·
Bunker Hill Monument (Boston and Sandwich
Glass Co.), c. 1840
Cup plate, glass, 3 3/4 diameter
*Lent from the Collections of the Henry Ford
Museum*

BOOKS

152 ·{plate 82}·
Wolverine
From John James Audubon, *The Quadrupeds of
North America,* New York, 1849–54, pl. XXVI,
pt. 6
*Lent by The University of Michigan Library,
Department of Rare Books and Special Collections*

153 ·{plate 29}·
Washington
Frontispiece (lithograph by E. B. and E. C. Kel-
logg) to William Henry Brown (1808–1883), *Por-
trait Gallery of Distinguished American Citizens,*
Hartford, 1845
*Lent by the William L. Clements Library, The
University of Michigan*

154 ·{plate 61}·
Straight Line and Deviations
From Rembrandt Peale (1778–1860), *Graphics:
Manual of Drawing and Writing for the Use of
Schools and Families,* Second Edition, Improved,
Philadelphia, 1838, p. 84
*Lent by the William L. Clements Library, The
University of Michigan*

155 ·{plate 60}·
Crockett Delivering His Celebrated War Speech
From *Davy Crockett's 1847 Almanac* (no author),
Boston, 1846, unpaginated
Lent by the American Antiquarian Society

Plates.

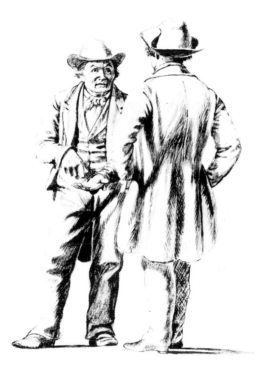

18. George Caleb Bingham, *Two Citizens*, 1851–52

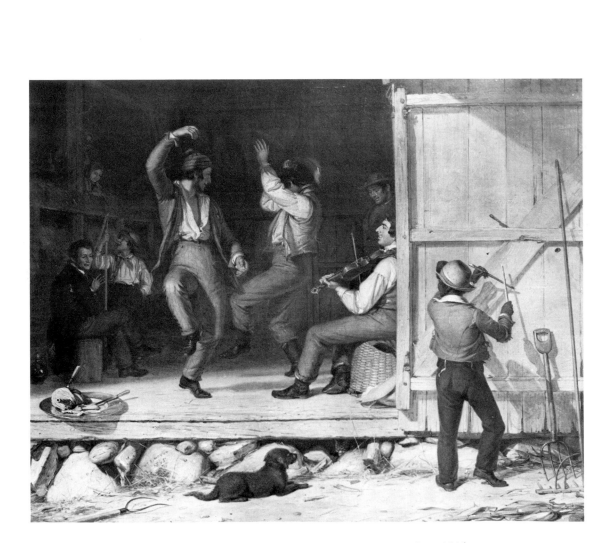

105. William Sidney Mount, *The Dance of the Haymakers*, 1845

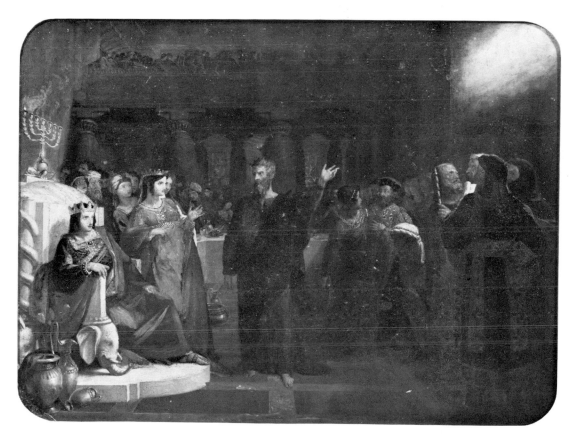

3. Washington Allston, *Study for the Feast of Belshazzar*, 1817

17. George Caleb Bingham, *Two Citizens Conversing,* 1851–52

19. George Caleb Bingham, *Early Celebrants,* 1851–52

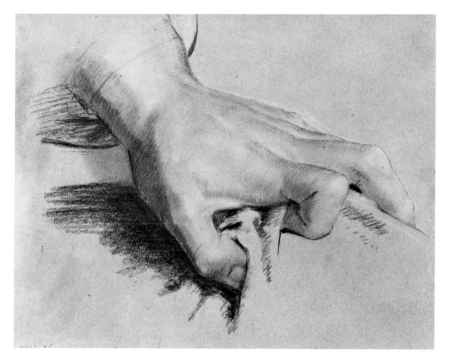

8. Washington Allston, *Left Hand of Belshazzar*

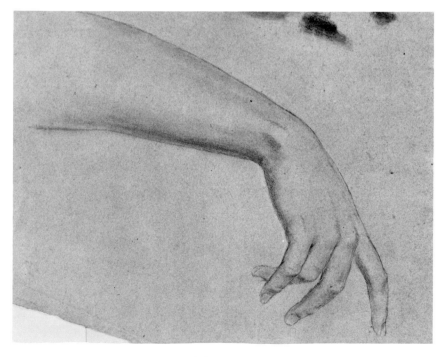

11. Washington Allston, *Hand and Forearm*

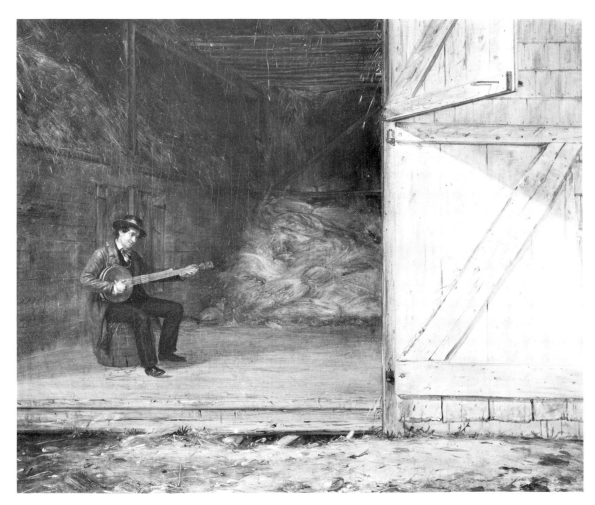

103. William Sidney Mount, *Banjo Player*, c. 1855

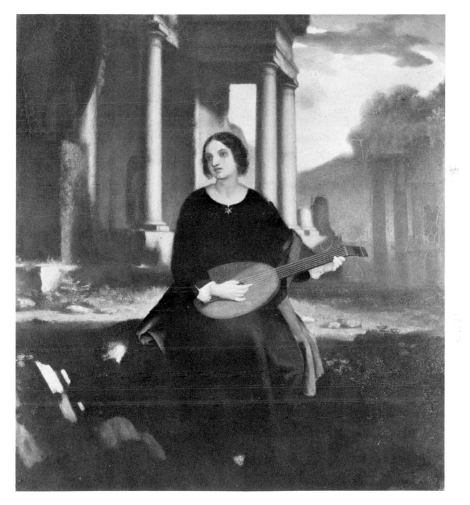

2. Washington Allston, *The Evening Hymn*, 1835

28. Jefferson Chalfant, *Violin and Bow*, 1889

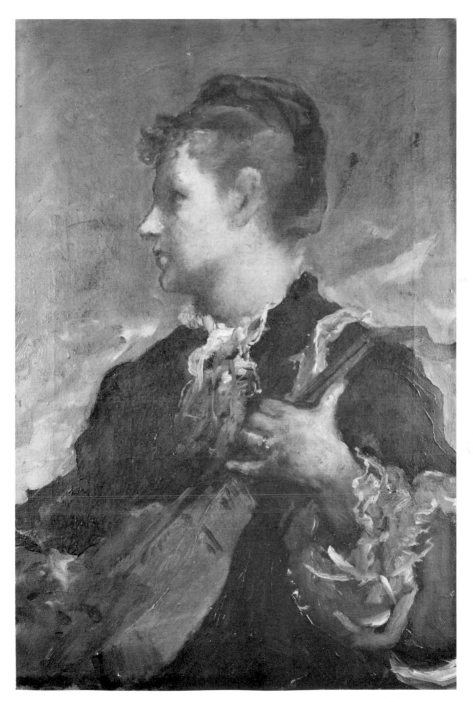

98. William Morris Hunt (attrib. to), *Young Woman with a Guitar*

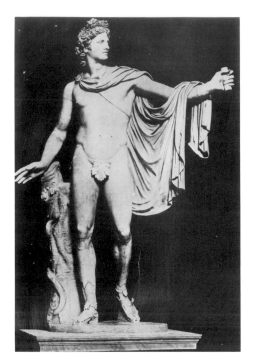

129. Unknown, *Apollo Belvedere*

21. George Caleb Bingham, *Hearty Drinker*, 1851–52

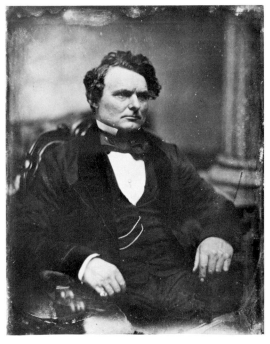

72. Thomas Eakins, *William H. MacDowell*

122. Albert S. Southworth and Josiah J. Hawes, *Donald McKay*, 1855

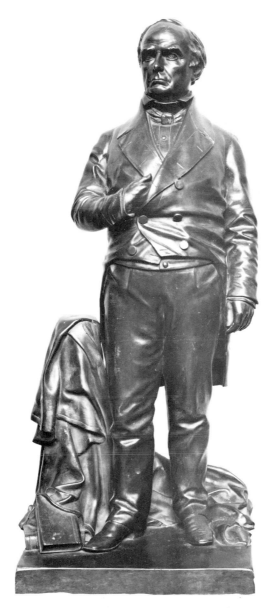

132. Thomas Ball, *Daniel Webster*, 1853

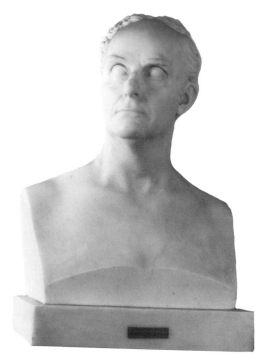

135. Hiram Powers, *Bust of Daniel Webster*, 1837 (?)

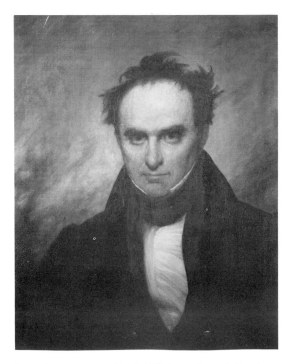

1. Francis Alexander, *Daniel Webster (Black Dan)*, 1835

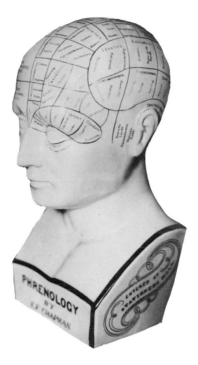

138. E. F. Chapman (attrib. to), *Phrenological Head,* mid 19th c.

99. Henry Inman, *William C. Macready,* c. 1827

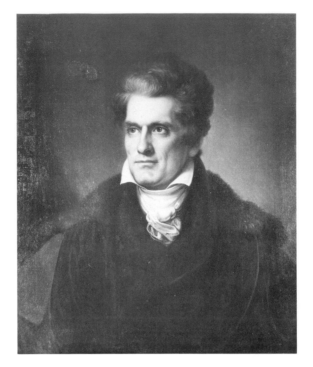

113. Rembrandt Peale, *Portrait of John Calhoun*, 1838

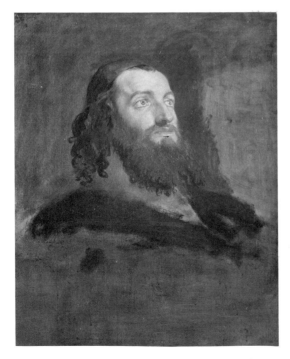

4. Washington Allston, *Head of a Jew*, 1817

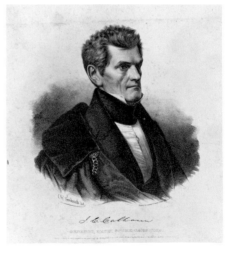

74. Charles Fenderich, *John Calhoun*, 1837

68. Thomas Eakins, *Portrait of William H. MacDowell*

93. George P. A. Healy, *Portrait of Daniel Webster*, 1852

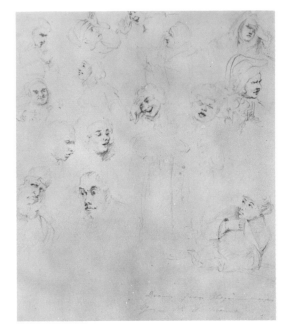

108. William Sidney Mount, *Drawings from Hogarth's Heads*

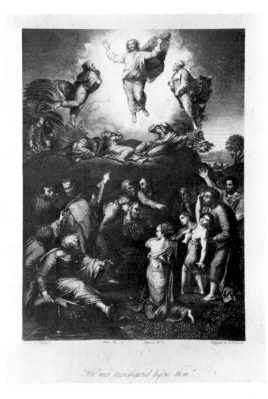

118. Raphael (engraving after), *He Was Transfigured before Them*

6. Washington Allston, *Portrait Study: Profile of a Man*

7. Washington Allston, *Female Head*

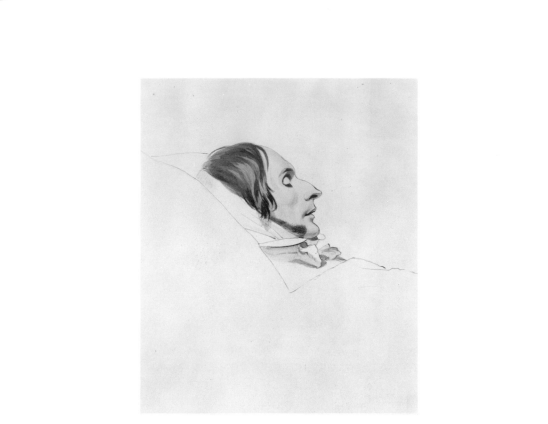

110. William Sidney Mount, *Henry S. Mount on His Death Bed*, 1841

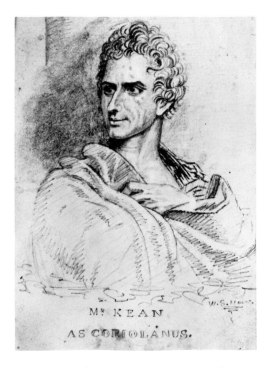

109. William Sidney Mount, *Mr. Kean as Coriolanus*

20. George Caleb Bingham, *Intoxicated Citizen*, 1851–52

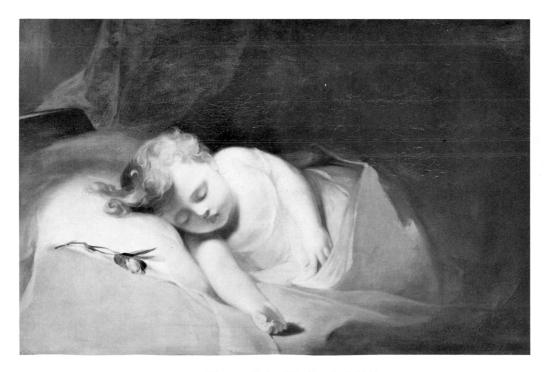

124. Thomas Sully, *The Rosebud*, 1841

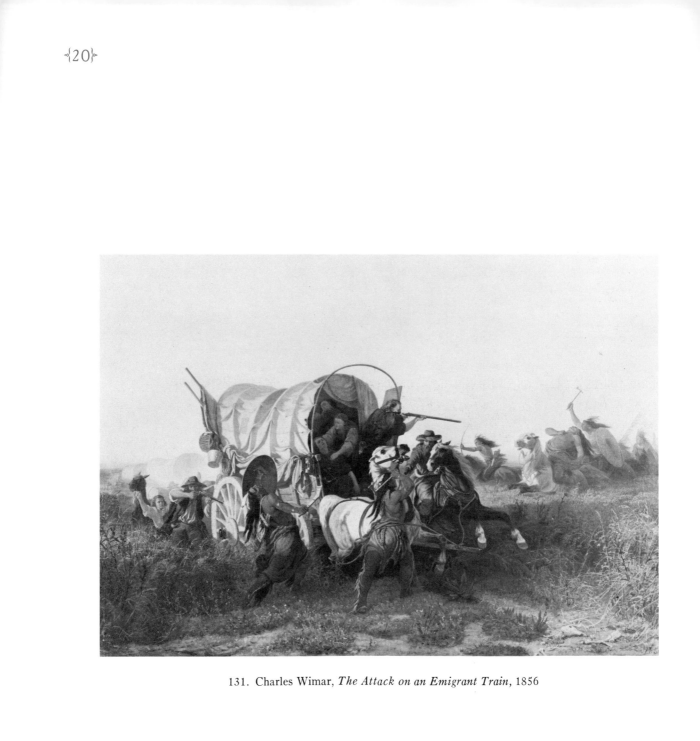

131. Charles Wimar, *The Attack on an Emigrant Train*, 1856

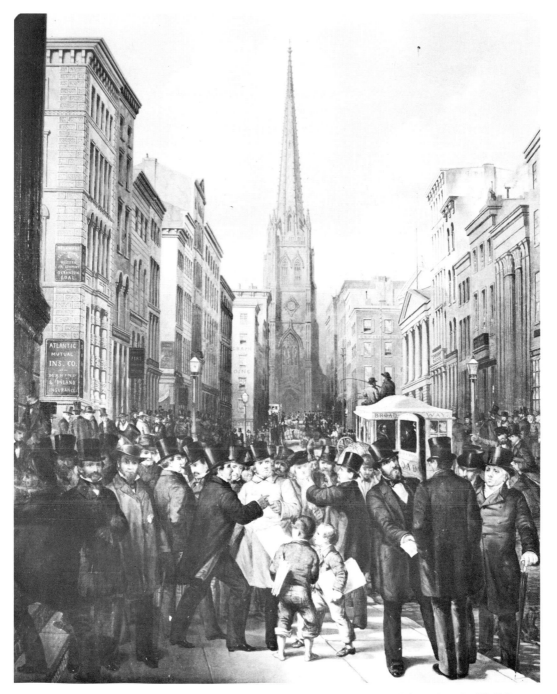

27. James H. Cafferty and Charles G. Rosenberg, *A Painting of the Revulsion of 1857. Wall Street, half past 2 o'clock. Oct. 13, 1857*, 1858

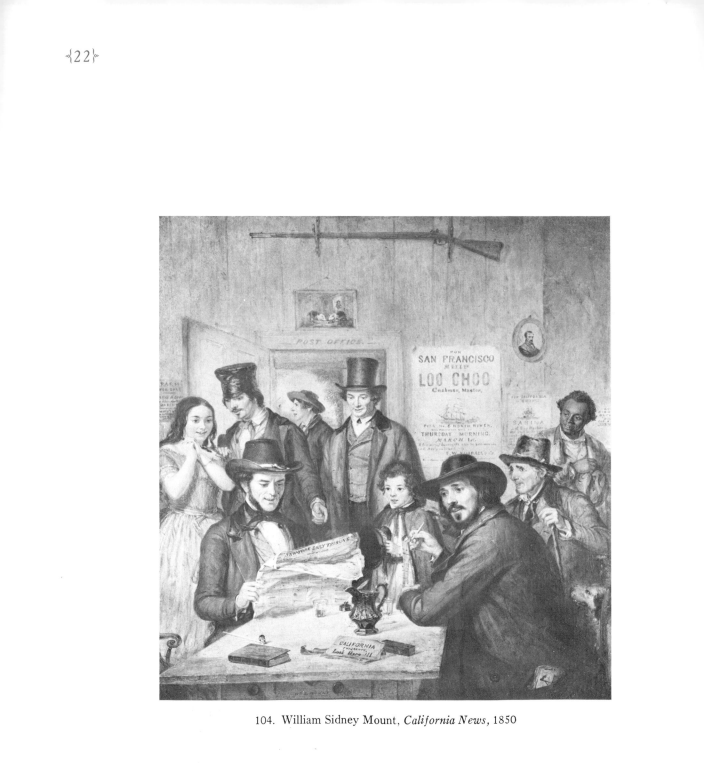

104. William Sidney Mount, *California News,* 1850

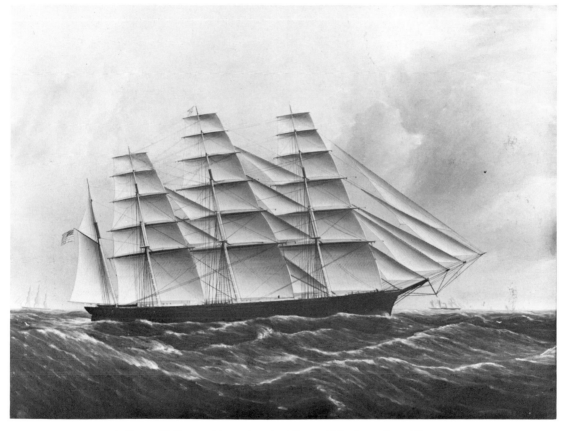

25. James E. Butter(s)worth, *The Clipper Ship Great Republic*, 1853

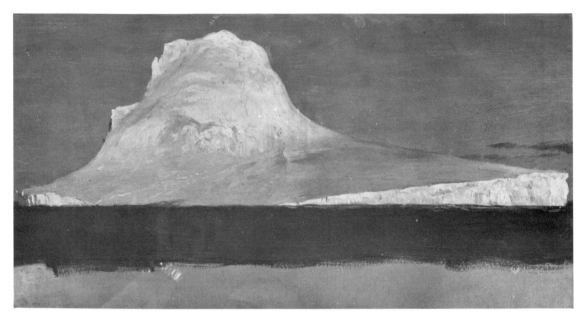

34. Frederic Edwin Church, *Sketch of an Iceberg*, 1859

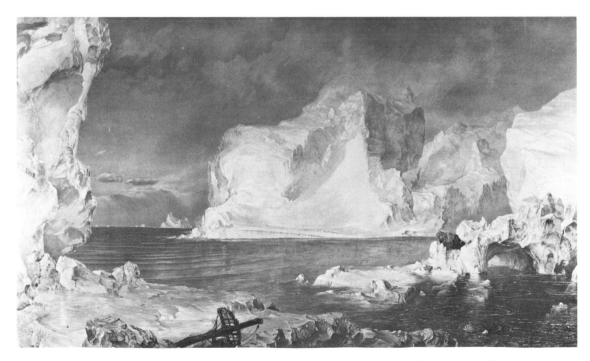

33. Frederic Edwin Church, *The Icebergs (The North)* [print by C. Risdon after Church]

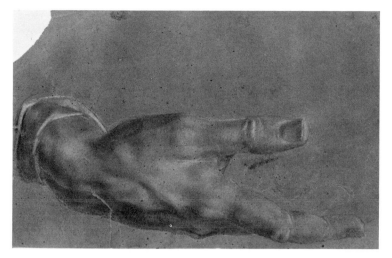

9. Washington Allston, *Man's Hand*

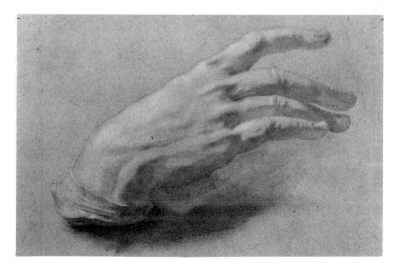

10. Washington Allston, *Hand*

137. Donald McKay, *Great Republic*, c. 1853

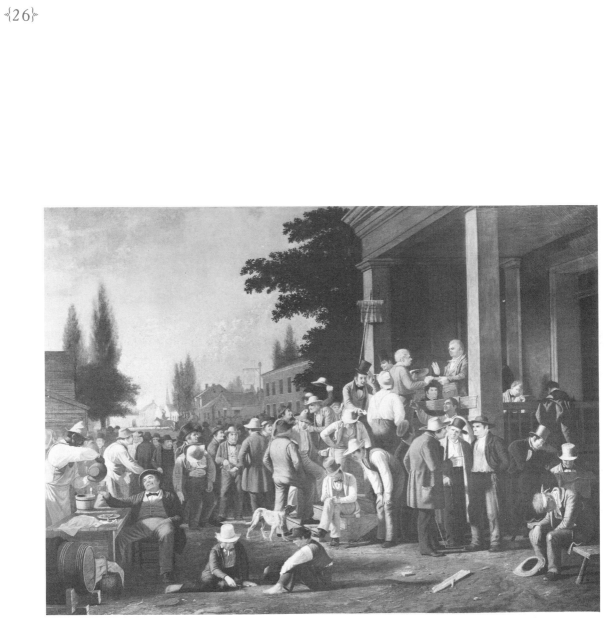

16. George Caleb Bingham, *The County Election*, 1851–52

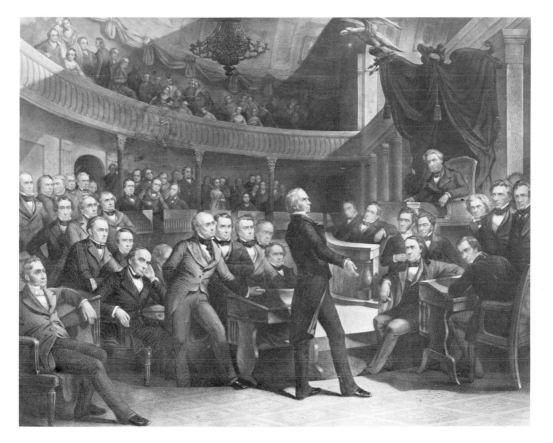

120. Peter Frederick Rothermel (engraving after), *United States Senate*, c. 1850–51

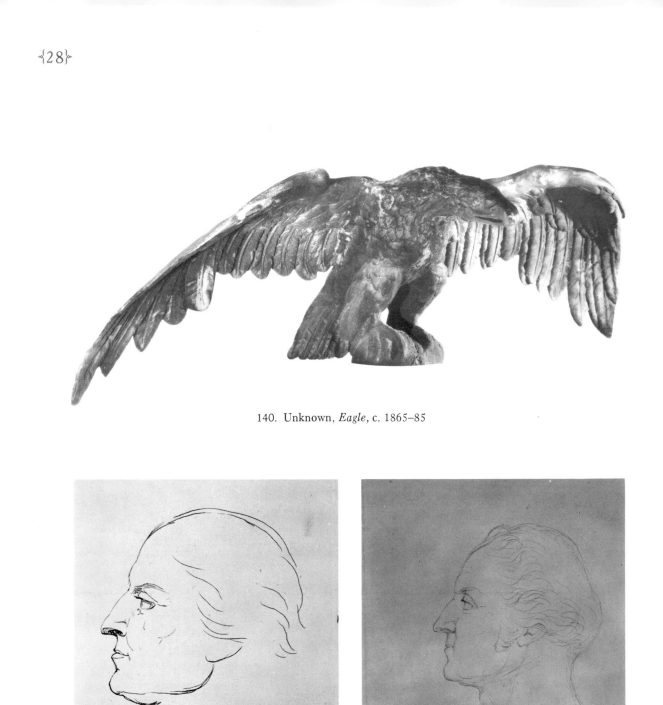

140. Unknown, *Eagle*, c. 1865–85

85. Horatio Greenough, *Head of Washington*,
1832–36

84. Horatio Greenough, *Head of Washington*,
1832–36

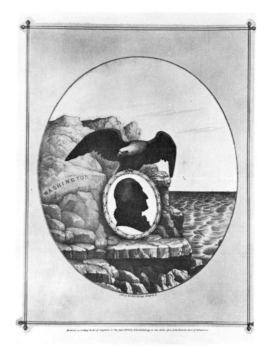

153. E. B. and E. C. Kellogg, *"Washington"* (frontispiece to William **Henry** Brown, *Portrait Gallery of Distinguished American Citizens*), 1845

121. Albert S. Southworth and Josiah J. Hawes, *Daniel Webster*, 1850

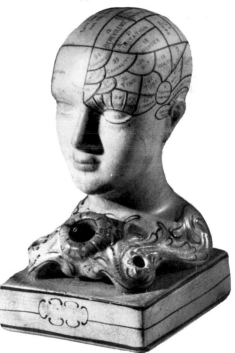

139. Unknown, *Phrenological Head*, 1850–59

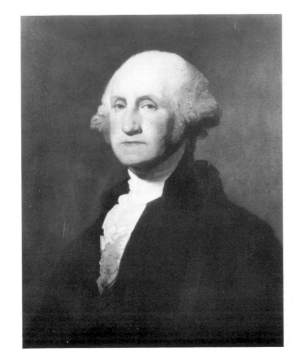

123. Gilbert Stuart, *Portrait of George Washington (The Allibone Portrait)*

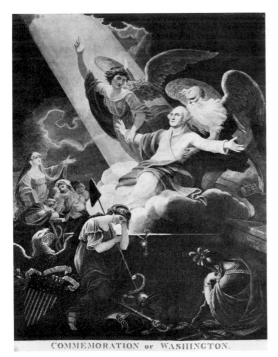

14. John James Barralet, *Commemoration of Washington*

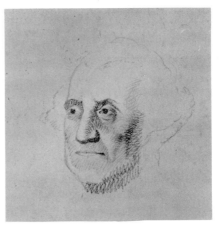

83. Horatio Greenough,
Head of Washington, 1826–27

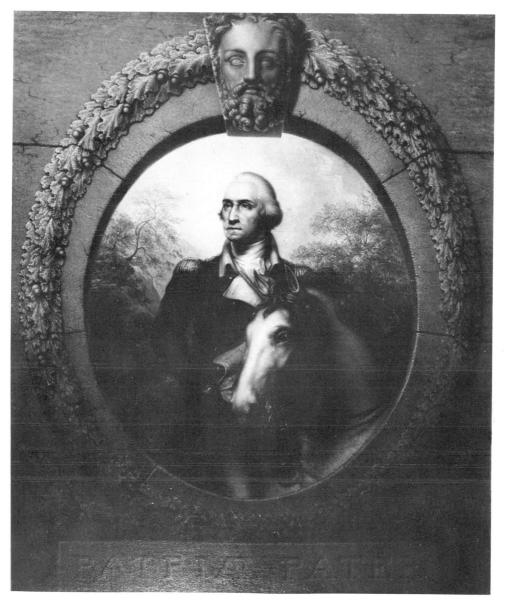

114. Rembrandt Peale, *Washington before Yorktown*, 1850

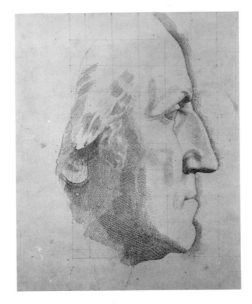

86. Horatio Greenough, *Head of Washington after Houdon*, 1834

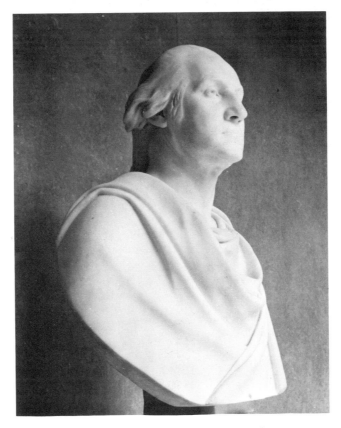

136. Randolph Rogers, *Bust of George Washington*, 1868

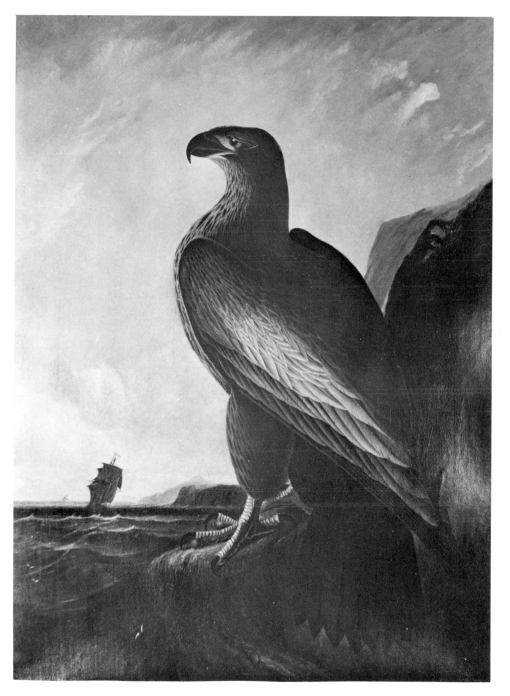

12. John James Audubon, *The Eagle of Washington*, 1837

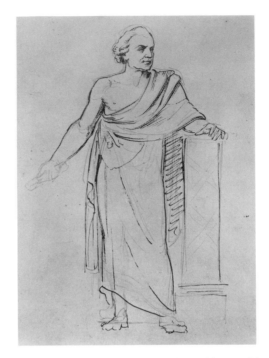

88. Horatio Greenough, *Studies for the Statue of Washington* (detail), 1832

87. Horatio Greenough, *Pedestal for "Washington,"* 1841–43

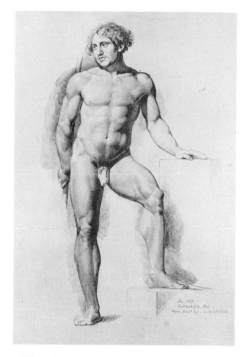

80. Horatio Greenough, *Nude Man, Front,* 1830

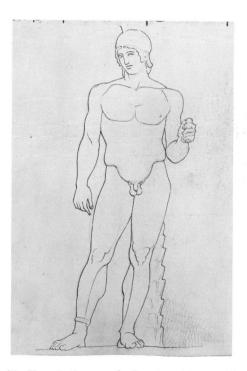

79. Horatio Greenough, *Borghese Mars,* 1826

69. Thomas Eakins, *Nude Woman Reclining, Back Turned*, c. 1866

48. Thomas Cole, *Gnarled Tree Trunk*

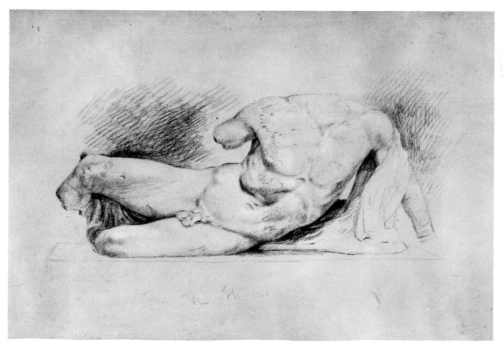

Thomas Cole, *Ilissus or Kefissos*, 1841 or 1842

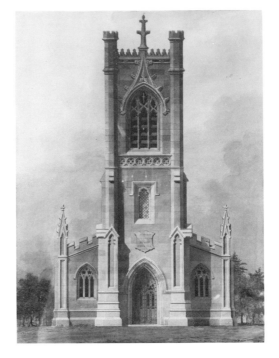

65. Alexander Jackson Davis, *Design for a Chapel in the Gothic Style,* c. 1835

67. Alexander Jackson Davis, *Monumental Cemetery Entrance in Egyptian Style,* c. 1830–35

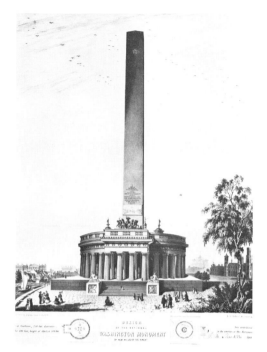

75. Charles Fenderich, *Design of the National Washington Monument by Robt. Mills of S. C. Archt.*, 1846

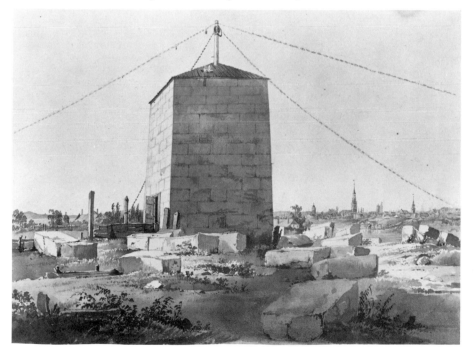

22. Karl Bodmer, *The Bunker Hill Monument on Breed's Hill near Boston as It Was in the Year 1832*, 1832

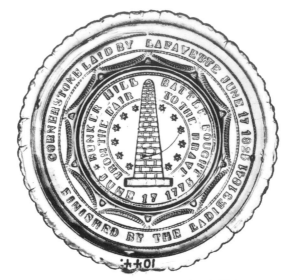

151. Boston and Sandwich Glass Co., *Bunker Hill Monument*, c. 1840

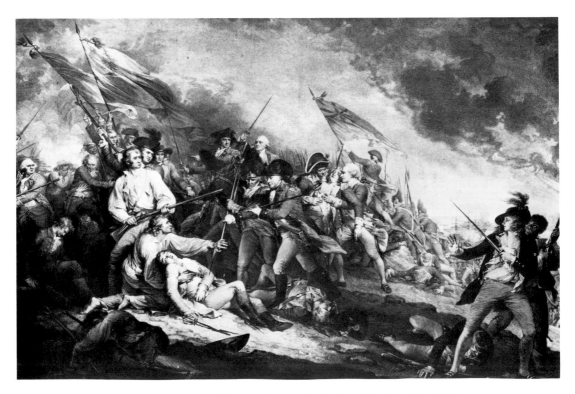

126. John Trumbull (engraving after), *Battle of Bunker Hill*, 1798

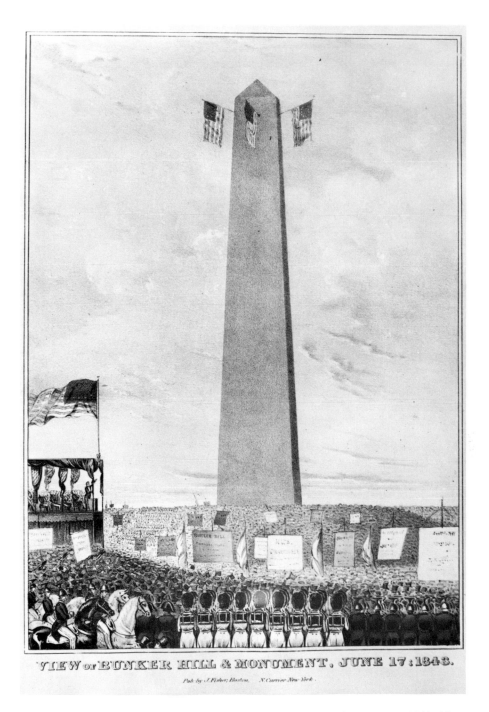

VIEW OF BUNKER HILL & MONUMENT, JUNE 17:1843.

Pub. by J. Fisher, Boston. N. Currier New York.

56. Nathaniel Currier; J. Fisher, *View of Bunker Hill and Monument*, c. 1843–46

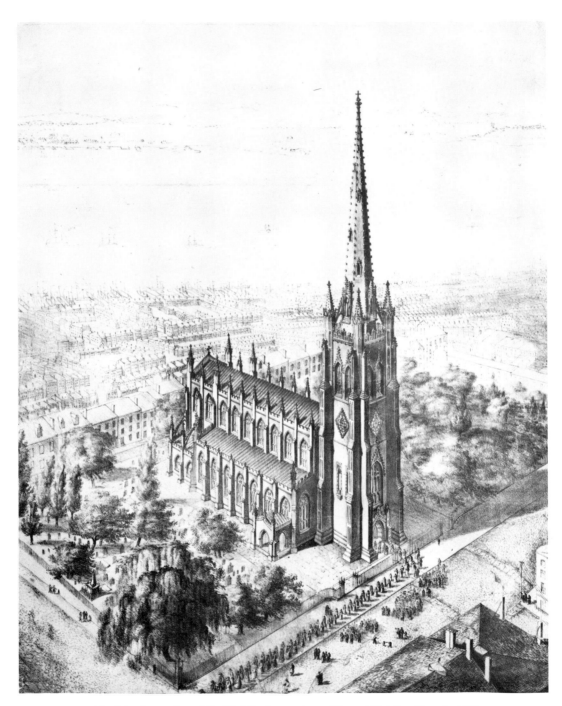

76. John Forsyth and E. W. Mimée, *Birdseye View of Trinity Church*, 1847

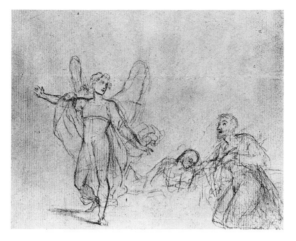

5. Washington Allston, *Angel and Peter*, c. 1812

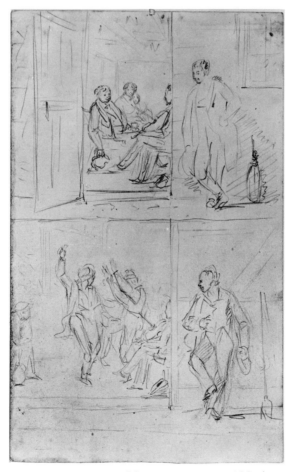

107. William Sidney Mount, *The Power of Music;
The Dance of the Haymakers*, c. 1845

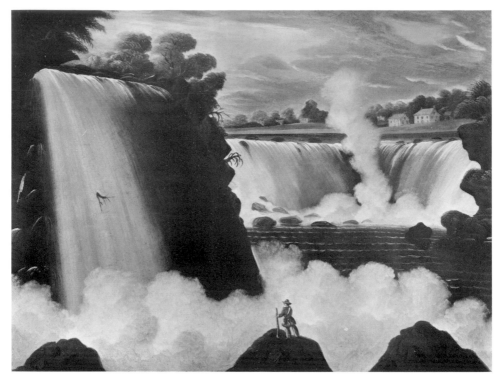

29. Thomas Chambers, *Niagara Falls*, c. 1820–40

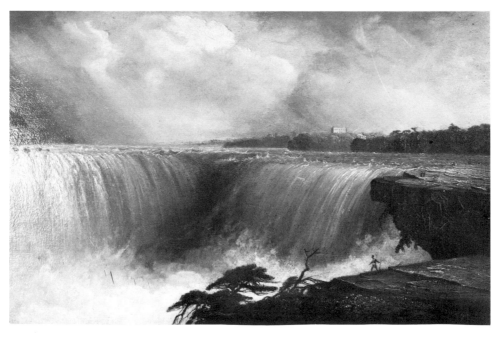

40. Thomas Cole, *Niagara Falls*, c. 1829–30

97. William Morris Hunt, *Niagara Falls*, c. 1878

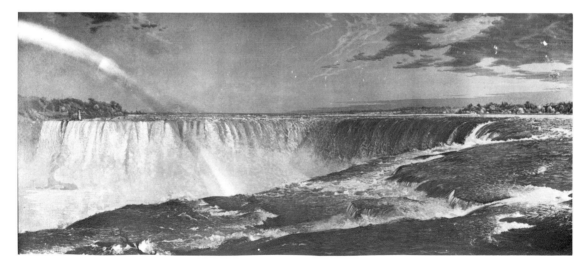

32. Frederic Edwin Church [after], *Niagara*, c. 1857

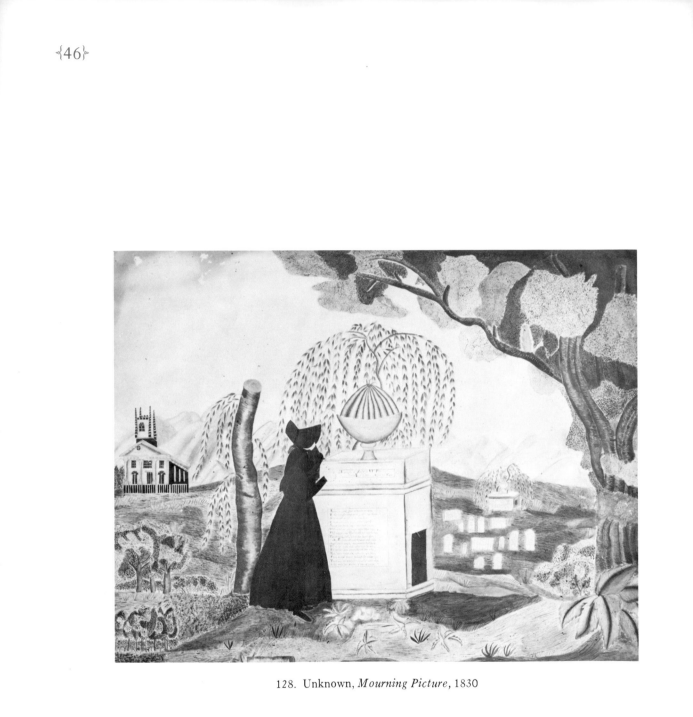

128. Unknown, *Mourning Picture*, 1830

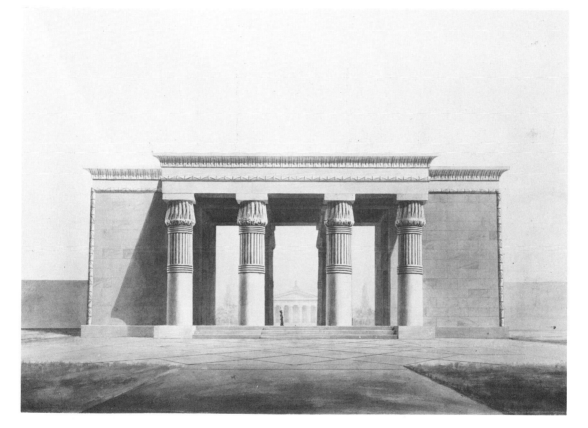

66. Alexander Jackson Davis, *Monumental Cemetery Entrance in Egyptian Style*, c. 1830–35

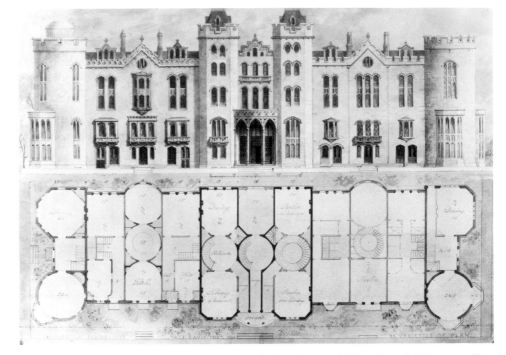

64. Alexander Jackson Davis, *Preliminary Study for House of Mansions, 5th Avenue: Front Elevation and Ground Plan,* 1858

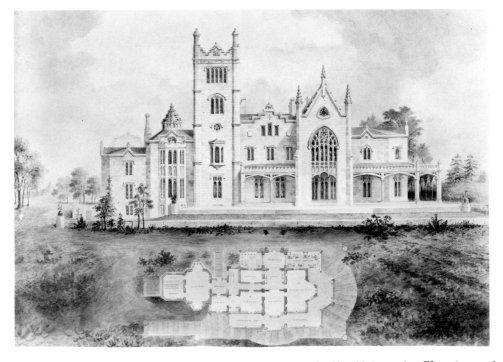

62. Alexander Jackson Davis, *Lyndhurst* (Paulding/Merritt/Gould House): *Elevation and Ground Plan* (detail from larger drawing), 1865

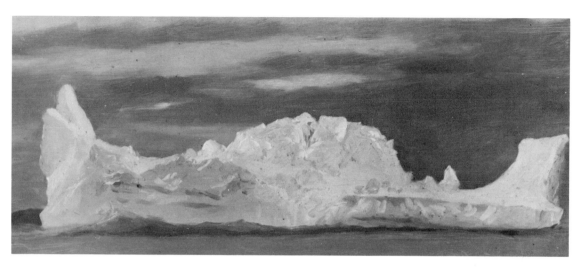

36. Frederic Edwin Church, *Sketch of an Iceberg*, 1859

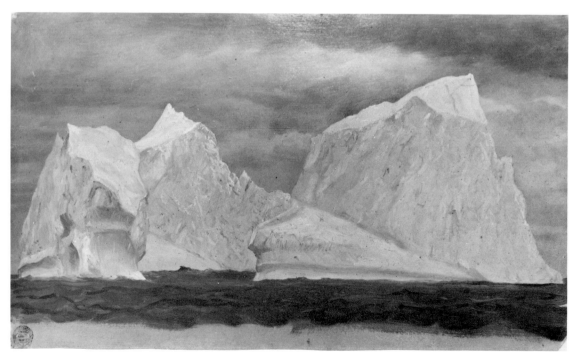

36. Frederic Edwin Church, *Sketch of an Iceberg*, 1859

23. W. van de velde Bonfield, *Drifting Snow*

100. George Inness, *Sunnyside*, 1847 (after)

38. Thomas Cole, *The Departure*, 1837

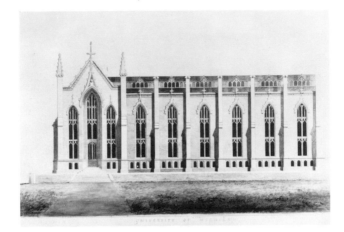

59. Alexander Jackson Davis, *The University of Michigan Project:
North Wing*, 1838

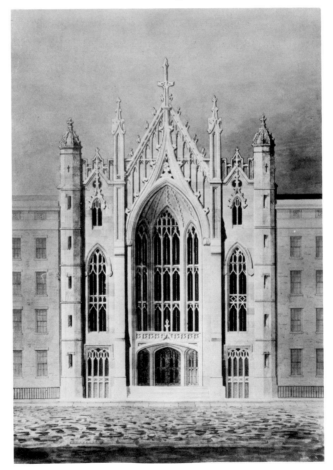

58. Alexander Jackson Davis, *The University of Michigan Project:
Study for a Gothic Entrance*, 1838

57. Alexander Jackson Davis, *The University of Michigan Project:
Plan of Campus Set in Green Lawn,* 1838

61. Alexander Jackson Davis, *Lyndhurst* (Paulding/Merritt/Gould House)*:
Elevation and Plans of Paulding House,* 1838

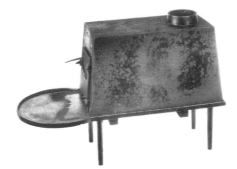

146. Unknown, *Shaker Box Stove*, c. 1850

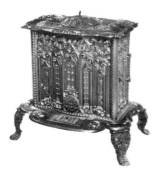

147. E. Huntington, Elmira, New York, *Parlor Heating Stove*, 1847

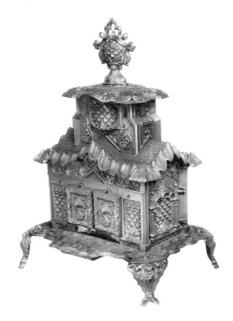

148. Samuel D. Vose & Co., Albany, New York, *Upright Parlor Heating Stove*, 1854

130. Unknown, *Advertisement for "H. Purves Stove Co."*

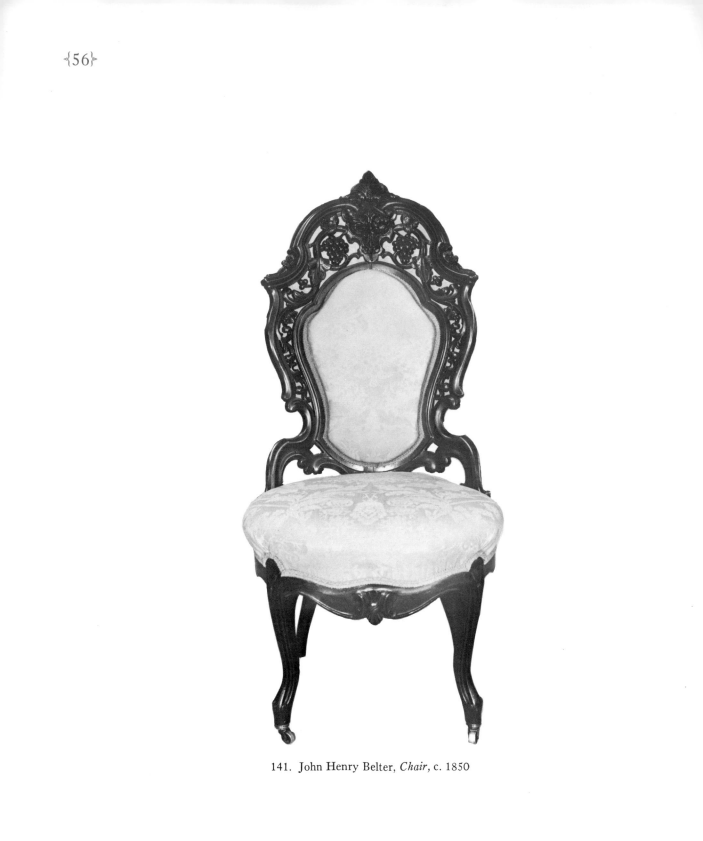

141. John Henry Belter, *Chair*, c. 1850

119. Severin Roesen, *Still Life*, c. 1850–55

112. James Peale, *Still Life: Fruit*

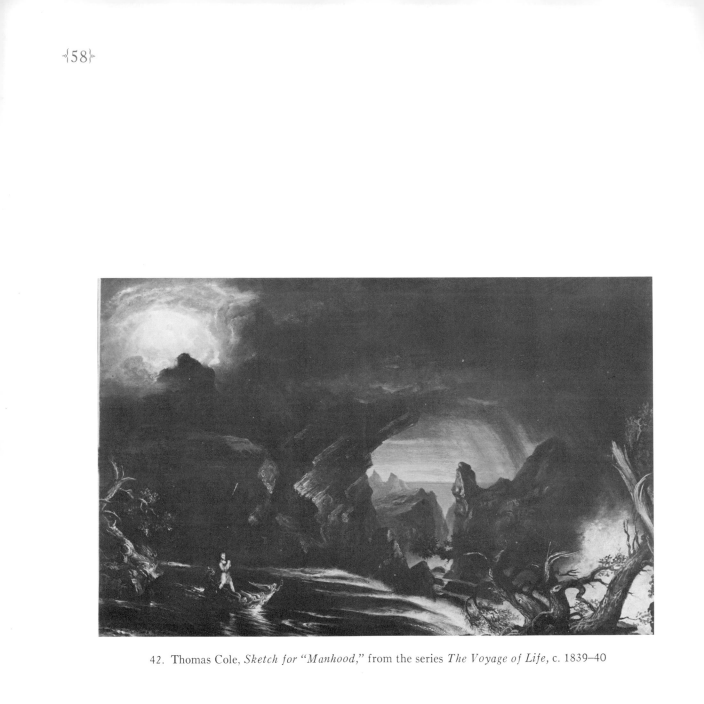

42. Thomas Cole, *Sketch for "Manhood,"* from the series *The Voyage of Life,* c. 1839–40

125. Hanna Ann Treadway, *Holy Mother Wisdom to Hanna Ann Treadway*, 1845

155. Unknown, *Crockett Delivering His Celebrated War Speech*
(from *Davy Crockett's 1847 Almanac*), 1846

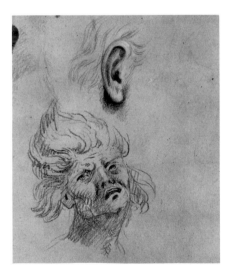

44. Thomas Cole, *Ear and Grotesque Face*

45. Thomas Cole, *Grotesque Face*, 1831

50. Thomas Cole, *Trunk of a Butternut Tree*

47. Thomas Cole, *Cliff Suggesting
Man's Face*, 1841

154. Rembrandt Peale, *Straight Line and Deviations*
(from *Graphics: Manual of Drawing
and Writing for the Use of Schools and Families*), 1838

51. Thomas Cole, *Shuddering Tree*

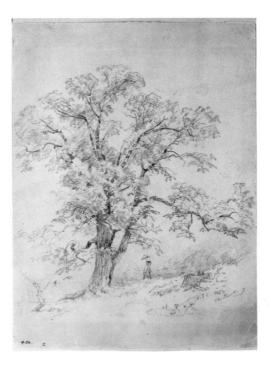

54. Jasper Francis Cropsey, *Chestnut Tree*, 1854

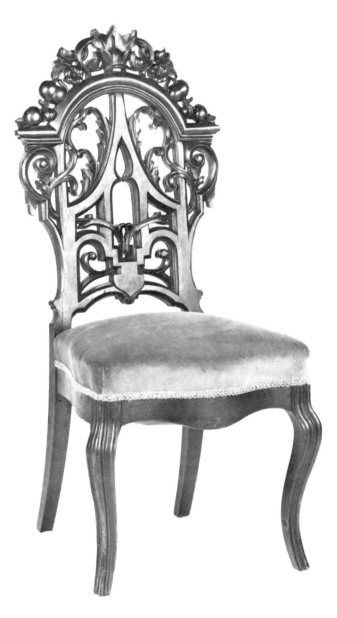

143. Unknown, *Chair*, c. 1850

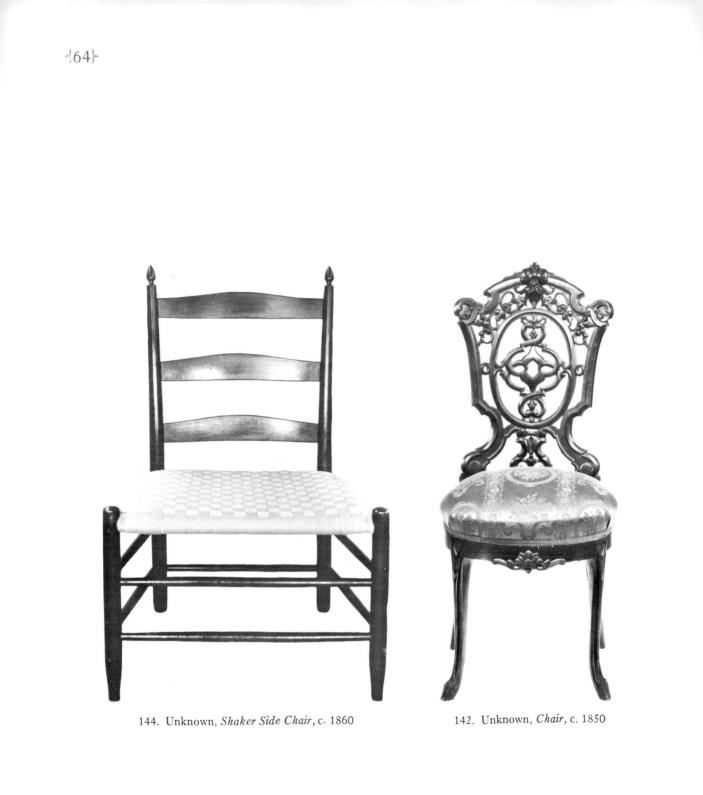

144. Unknown, *Shaker Side Chair*, c. 1860

142. Unknown, *Chair*, c. 1850

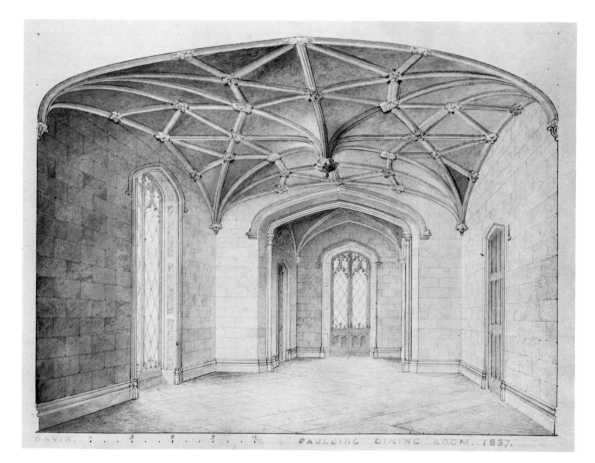

DAVIS. 3 6 9 12 PAULDING DINING ROOM. 1837.

63. Alexander Jackson Davis, *Lyndhurst* (Paulding/Merritt/Gould House) :
Interior Perspective of Dining Room, 1837

111. William Sidney Mount, *Drawings for Mount House Kitchen*

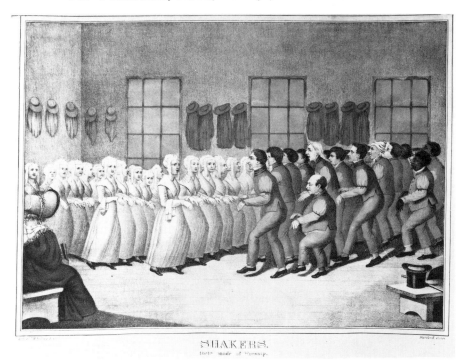

SHAKERS.
their mode of worship.

101. Daniel Wright Kellogg, *Shakers, Their Mode of Worship*, c. 1840

116. John Quidor, *Wolfert's Will*, 1856

13. Victor G. Audubon (attrib. to) and John W. Audubon (attrib. to),
Startled Deer—A Prairie Scene, c. 1848

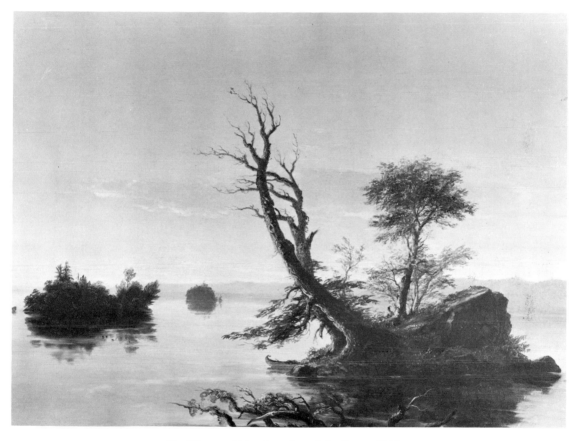

39. Thomas Cole, *American Lake Scene*, 1844

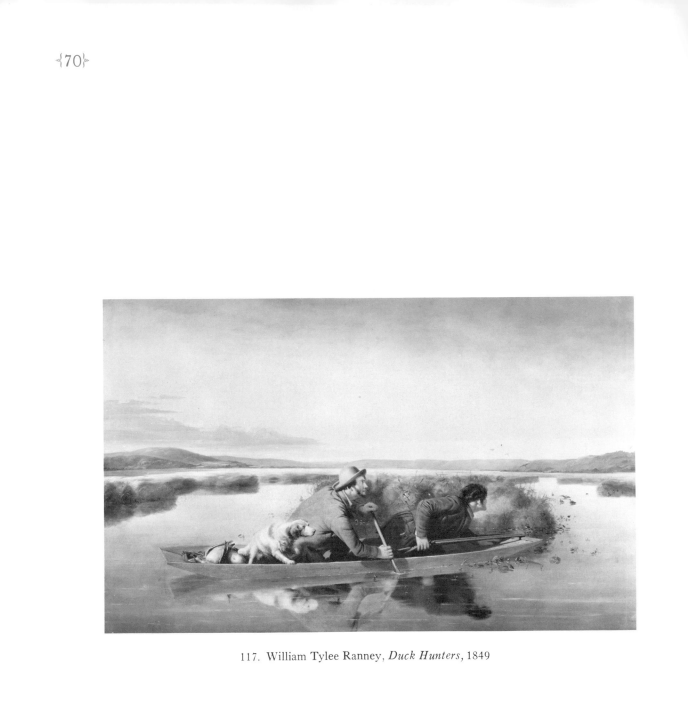

117. William Tylee Ranney, *Duck Hunters*, 1849

78. J. M. Gibbs, *The Chase*, c. 1850

46. Thomas Cole, *Twilight Sky of a Melancholy Expression*, 1845

37. Frederic Edwin Church, *Sketches of Icebergs*, 1859

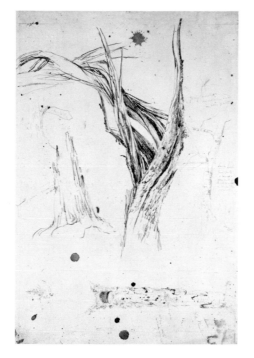

49. Thomas Cole, *Studies of Tree Trunks*, c. 1857

52. Thomas Cole, *Landscape with Italian Villa and Trees*

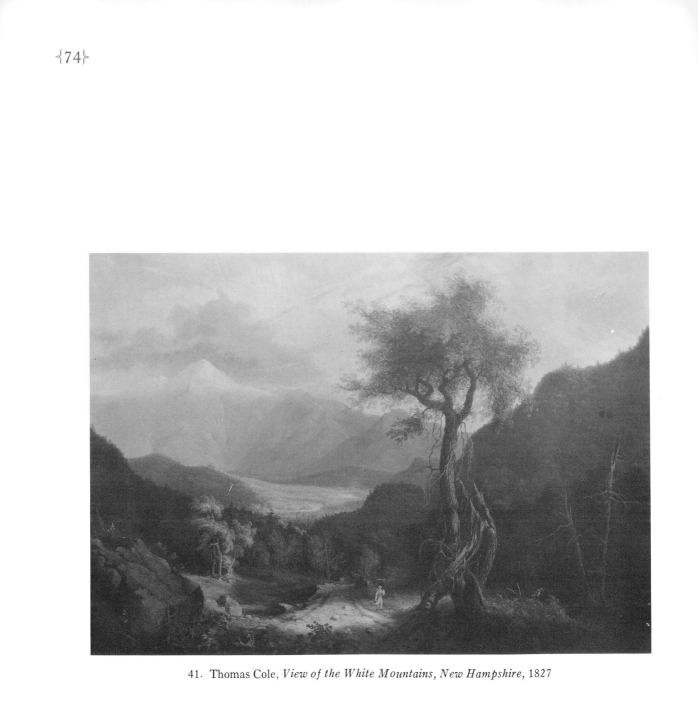

41. Thomas Cole, *View of the White Mountains, New Hampshire*, 1827

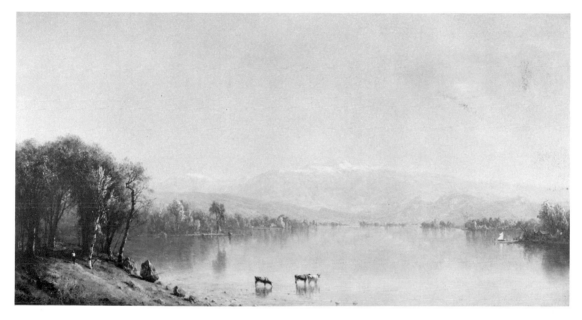

53. Jasper Francis Cropsey, *Mount Washington from Lake Sebago, Maine*, 1871

94. Edward Hicks, *The Peaceable Kingdom,* c. 1830–40

24. Eliphalet Brown and Charles Severin, *Barnum's American Museum*, 1851

24. detail

24. detail

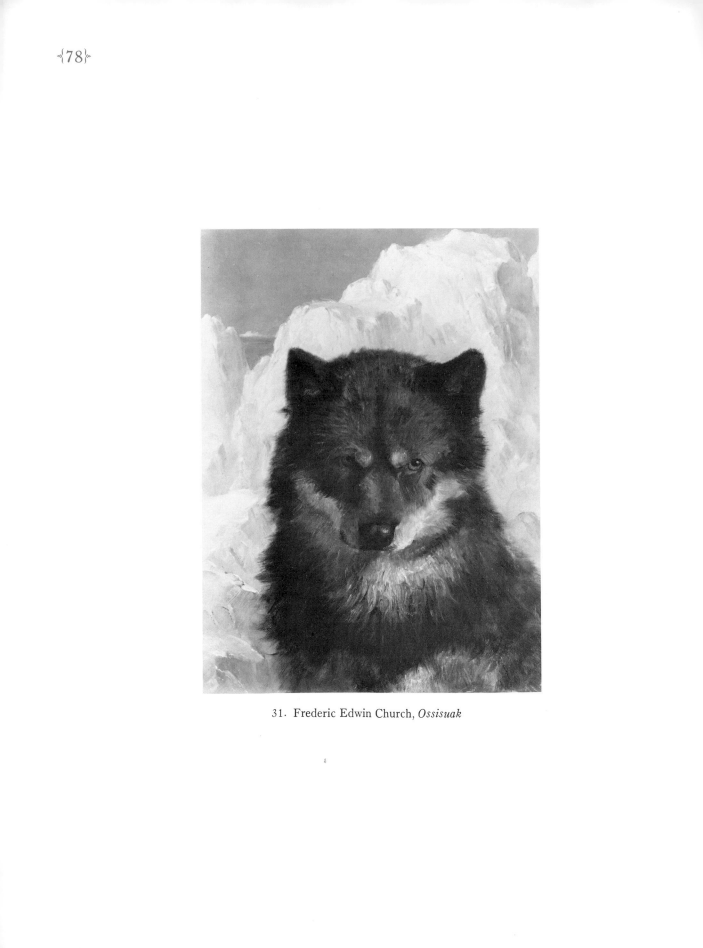

31. Frederic Edwin Church, *Ossisuak*

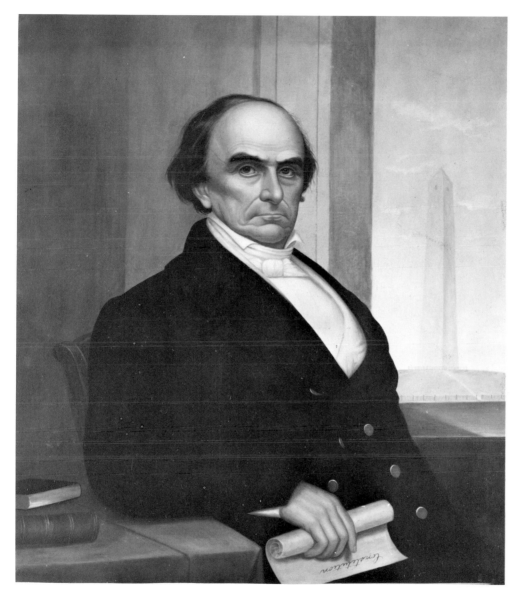

30. Joseph Goodhue Chandler, *Webster at Bunker Hill*

15. William H. Beard, *Susanna and the Elders*, 1865

106. William Sidney Mount, *Ringing the Pig*, 1842

73. Thomas Eakins, *Eakins Dog—Nance*

152. John James Audubon, *Wolverine* (from *Quadrupeds of North America*), 1849–54

115. Alexander Pope, *The Trumpeter Swan*, 1911

77. Charles Lewis Fussell, *Academy Students Dissecting a Horse*, 1879

133. Thomas Eakins, *Horse Skeleton*, 1878

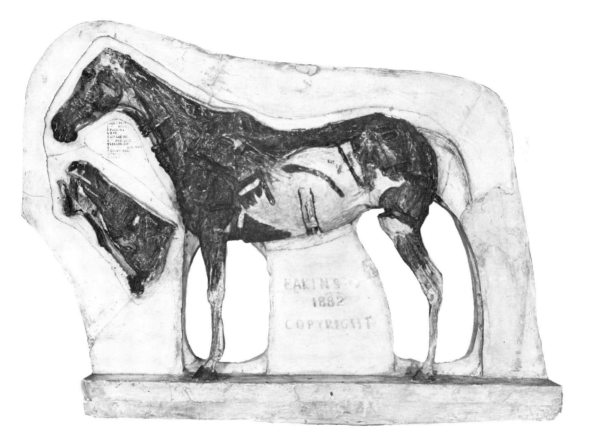

134. Thomas Eakins, *The Mare "Josephine" Ecorché,* 1882

82. Horatio Greenough, *Anatomical Study of a Leg*, 1832

71. Thomas Eakins, *Anatomical Drawing:*
Human Knee, Bone, Horse's Head, 1878

91. Horatio Greenough, *Horse of Selene
from the Parthenon Pediment, Left Corner*, 1832

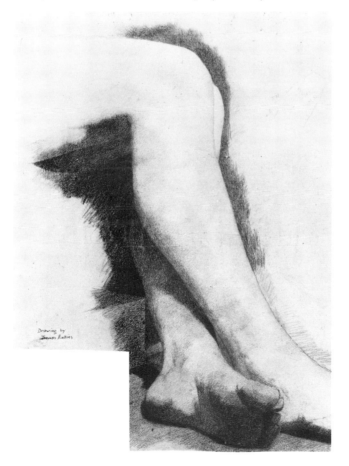

70. Thomas Eakins, *Legs of Seated Model*

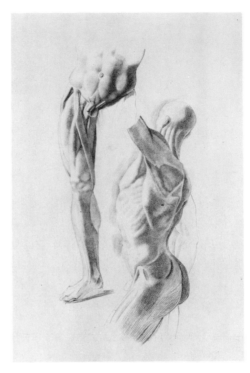

81. Horatio Greenough, *Study of Musculature of Legs and Torso of Nude Man,* 1832

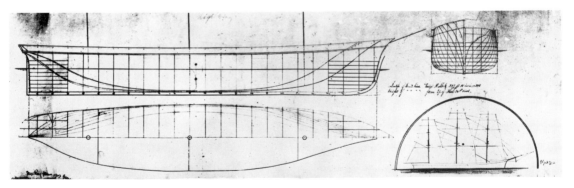

102. Donald McKay, *Original Plan of the Lines and Sail Plan of the Clipper Ship 'Lightning,'* 1853

90. Horatio Greenough, *Infant's Head; Woman's Head; Draped and Helmeted Figure...*, 1831

89. Horatio Greenough, *Designs for the Chair of the Washington Statue*, 1832–33

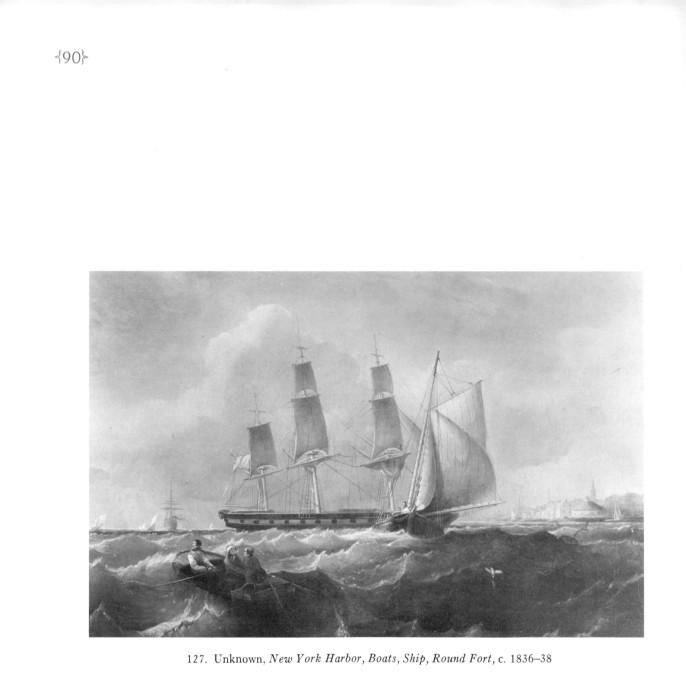

127. Unknown, *New York Harbor, Boats, Ship, Round Fort*, c. 1836–38

26. James E. Butter(s)worth, *Yacht America Leaving Boston Harbour*, c. 1870

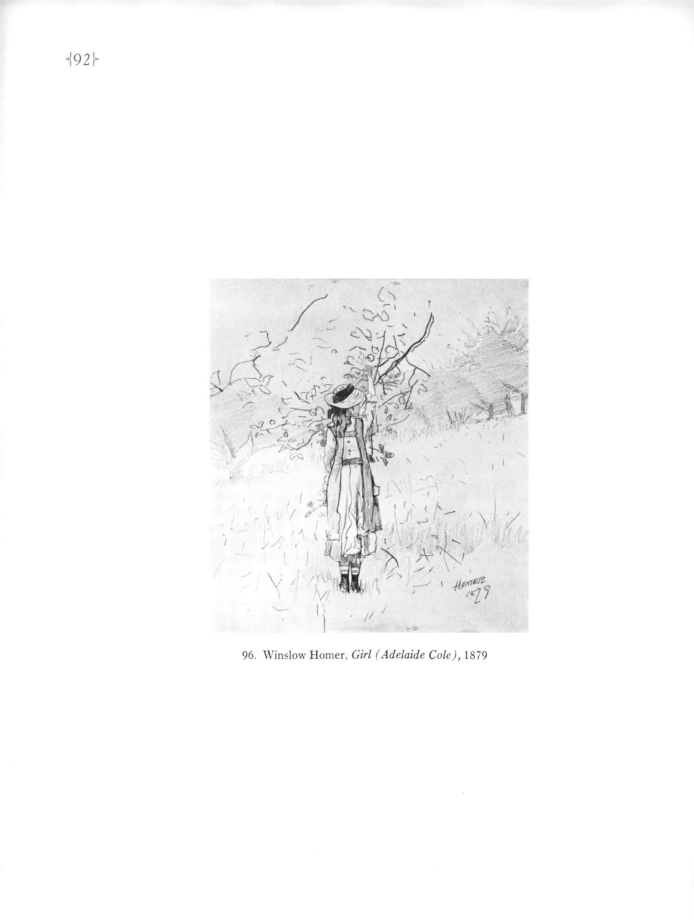

96. Winslow Homer, *Girl (Adelaide Cole)*, 1879

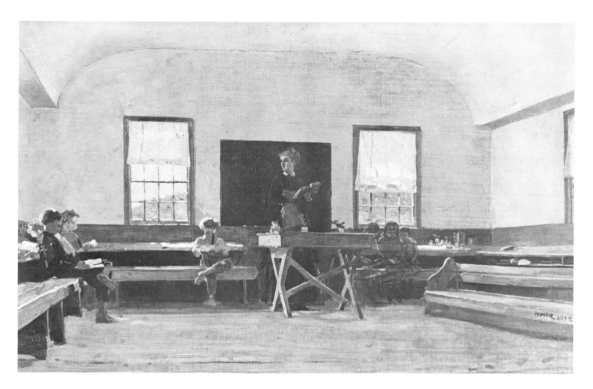

95. Winslow Homer, *The New England Country School*, 1872

PHOTO CREDITS

Brenwasser, New York, New York, nos. 2, 127
Chisholm & Kenyon, Inc., Houston, Texas, no. 115
Geoffrey Clements, New York, New York, no. 128
George M. Cushing, Boston, Mass., no. 135
Helga Photo Studio, Inc., New York, New York, no. 78
Lees Studio, no. 101
O. E. Nelson, New York, New York, no. 71
Charles Uht, no. 100
Herbert P. Vose, Wellesley Hills, Mass., no. 110
A. J. Wyatt, Staff Photographer, Philadelphia Museum of Art, no. 125

Editorial and design assistance by University Publications Office
Typesetting and printing by University Printing Services